IMAGES
of America

ANDOVER

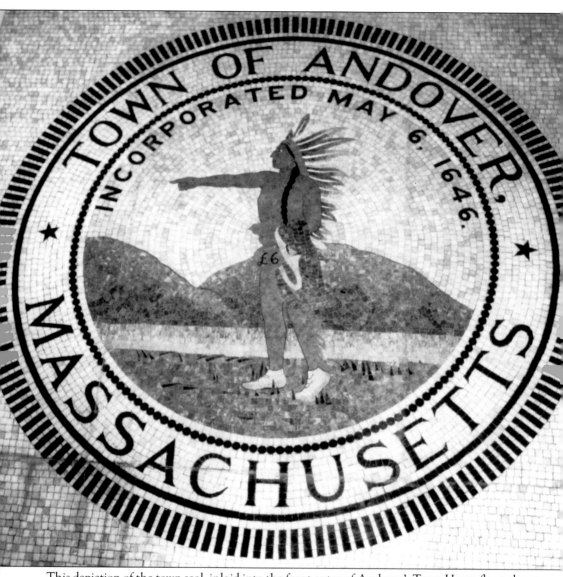

This depiction of the town seal, inlaid into the front entry of Andover's Town House floor, shows Cutsamache standing atop Indian Ridge, overlooking the land that will become Andover. In his hands are a pouch with six English pounds and a coat given to him by John Woodbridge, settler and first minister of the Andover Congregational Church.

On the cover: This image shows a bustling Main Street in 1946. The Barnard Building, Town House, Barnard Block, and Musgrove Building can all be seen. The Punchard/Ballard Mansion is in the far background. On the front steps of the Town House, two large tablets list Andover citizens who served in the armed forces during World War II. (Courtesy of the Andover Historical Society.)

IMAGES
of America

ANDOVER

Andrew Grilz
for the Andover Historical Society
Foreword by Norma Gammon

ARCADIA
PUBLISHING

Published by Arcadia Publishing
Charleston, South Carolina

Printed in the United States of America

Library of Congress Catalog Card Number: 2008935043

For all general information contact Arcadia Publishing at:
Telephone 843-853-2070
Fax 843-853-0044
E-mail sales@arcadiapublishing.com
For customer service and orders:
Toll-Free 1-888-313-2665

Visit us on the Internet at www.arcadiapublishing.com

This book is dedicated to the volunteers and members of the Andover Historical Society, who are the reason we do this; to my wife, Robin, who provided moral support and professional editorial assistance and tolerated my long hours and frequent absences while writing this book with untold patience and understanding; and to T. S., the best friend I could ever ask for. Thank you.

CONTENTS

ACKNOWLEDGMENTS

This book would not have been possible without the assistance and contribution of the following individuals: Andover Historical Society board members past and present Jim Batchelder, Jim Redmond, Donald Robb, and Joan Patrakis are to be thanked and enthusiastically applauded for reviewing, editing, and refining preliminary drafts and catching more than one embarrassing error. My most sincere gratitude goes to Andover Historical Society staff members Elaine Clements, Carrie Midura, and Sarah Scyz for support, encouragement, and running interference, allowing me to focus on research, writing, and assembling this book. I owe you all. Thanks to Andover Historical Society intern Steve Kellner for interrupting his own work to aid me at critical moments. Collections committee volunteer chair Ellen Marcus aided in locating essential documents and material. The assistance of Andover Historical Society volunteer researchers Leah Dearborn, Kay O'Neil, Mary Ellen Philback, Lorrie Schmick, and Tina Su in selecting, scanning, and processing images from the society's collection is greatly appreciated. Carol Majahad, executive director of the North Andover Historical Society, graciously took time out from her busy schedule to help me locate sites and information on the earliest history of Andover. Additional information from Dick Cromie, Bill Dalton, Bernice Haggerty, the staff at Phillips Academy, the Andover town clerk's offices, the Andover office of public safety, and Kathy Francisco of the Internal Revenue Service helped fill in the gaps and made the book that much better. Norma Gammon also provided valuable information as well as writing a wonderful foreword. Unless otherwise noted, all images appear courtesy of the Andover Historical Society.

FOREWORD

It seems the older I get, the more I want to learn about this great town.

Andover began as humble forest in a new land, purchased by settlers full of courage and the tenacity to bring about their dreams of living and working in a land that promised prosperity, freedom, and a new beginning. From those first inhabitants right up to the present day, we have strived as a community to make Andover the strong, viable, and memorable town it is today. This book is intended to explore the activities of those townspeople, their homes, their work, and their social events.

The Andover Historical Society has constantly provided a greater understanding of Andover's history through its exhibits, school programs, and preservation awareness. Many of our greatest historical treasures have been saved by concerned preservationists from callous remodeling or total obliteration. I am pleased to see the photographic collections of the society opened up to the public in this book and hope it will help to remind every reader what a treasure we share in Andover.

We must always honor the footsteps of our ancestors by remembering the powerful traditions we have, seize any opportunity to live up that example, and preserve our history as we move forward. In closing, I hope you enjoy this book as much as I have.

—Norma Gammon

INTRODUCTION

Andover is a community rich in history and steeped in tradition. It is one of the oldest towns in the commonwealth of Massachusetts and one of the oldest in the United States continuously governed by town meeting. In 1634, the great and general court of the colony of Massachusetts mapped and apportioned the fertile farm and fishing lands around Lake Cochichewick for future settlement. The town of Andover was founded on May 6, 1646, and established with the arrival of settlers from Ipswich, Rowley, and Newbury. John Woodbridge, acting on behalf of the general court, paid a local Pennacook Indian sachem named Cutsamache a total of £6 and a coat for a parcel of land called Cochichuate. This event has been memorialized in the Andover town seal.

Colonists established homes and farms, commonly known as freeholds, in the land now known as Andover. Some two dozen families were recorded as the first to settle in the new township by 1650. Many of those early family names are still found in Andover. One of these early settlers, Simon Bradstreet, went on to become Colonial governor. His wife, Anne, became famous in her own right. Her books of poetry were the first written in the New World.

In the 17th century, Andover was very much a frontier town, and colonists commonly interacted with the indigenous population. The contract by which Cutsamache agreed to sell the land that became Andover even included a provision for a Native American known by the Christian name Roger to continue to grow corn and harvest fish from the brook that ran through the new settlement. To this day, the stream is still known as "Roger's Brook."

Andover's relative isolation insulated the town from much of the violence of the Indian Wars, but Andover did not escape the long period of unrest entirely without incident. In December 1672, Joseph and Timothy Abbott, both teenagers, were attacked while working in the family fields. Joseph was killed, and Timothy was taken hostage for several months. In 1676, the general court ordered the settlement at Andover to become a garrison town, with wooden palisades erected to defend against attack. Still, altercations during the various Indian Wars were infrequent. In 1689, two brothers traveling from Andover to Haverhill were ambushed and killed. Col. Joseph Frye of Andover was captured, stripped, and marched through the woods to what he felt was probably certain death but overpowered his captors and escaped. Cattle were sometimes stolen, and farmhouses were occasionally burned, but Andover never suffered a full-fledged attack.

The end of the 17th century found the colonists at Andover enmeshed in the witchcraft hysteria that gripped the region. More than 40 people from Andover were arrested and imprisoned on suspicion of witchcraft, a greater number than in any other town involved in the witchcraft trials. Eight were tried and convicted. Even prominent community leaders such as

the Reverend Francis Dane, who vocally opposed the witch trials, and Judge Dudley Bradstreet, who wrote out the warrants for many of the accused, came under suspicion at the height of the frenzy. This has led some scholars to suspect the witchcraft hysteria in Andover may have had a particular political aspect.

Three people from Andover were executed before this most infamous event in New England history came to an end. Mary Parker, Martha Carrier, and Samuel Wardwell were hanged in August 1692, all protesting their innocence. Carrier's children, who were forced to testify against their mother at trial, later petitioned the court to reverse the verdict against their mother. They succeeded and also received £7 restitution for her death.

Water mill–powered industry has helped shape the economic and social structure of Andover nearly since its founding. The first mill is recorded as having been built in 1644, even before Andover was founded. Licenses to build a mill in Andover were issued by the general court in 1648, and several gristmills were built in the 17th century. As mills began to produce felt and other textiles, Andover became the first place in America where worsted wool was spun.

Andover, like many New England towns, contributed to the fight for American independence. Volunteer militias were sent to the battles of Lexington and Concord and aided in the counter offensive that pursued the British troops back from Concord to Cambridge. Salem Poor, a former slave and Andover native, became a famous icon of the Revolution for his actions and bravery at the battle of Bunker Hill.

Andover's mills also played a major role in the American Revolution. In January 1776, Samuel Phillips was engaged by the Continental Congress to produce gunpowder for the army. Phillips built a mill in the west of Andover along North Main Street and was producing gunpowder by March of that year, sooner than any other mill in Massachusetts. Gunpowder was in short supply until then, and Phillips's mill ran seven days a week to compensate, producing as much as 1,000 pounds of gunpowder per week. The manufacture of gunpowder was not without risk, however. The mill suffered three separate explosions, killing a total of five men. Following the final explosion in 1793, the mill became a paper mill for a time and was converted to textile work by William Marland in 1807.

The mill industry was an economic windfall for Andover in the early 19th century, and many residents made their fortunes from the factories. Men such as Marland, brothers John and Peter Smith, and John Dove established large textile-producing facilities along the Shawsheen River. Dove and the Smith brothers, who were Scottish immigrants, frequently recruited from their hometown of Brechin, Scotland, as well as other factory towns in Scotland, Ireland, and England to find inexpensive but experienced labor to operate their mills. Many other ethnic groups found a home in Andover as well. Armenian, Greek, German, Italian, and many other nationalities found work in the factories and fields of Andover throughout the 19th and early 20th centuries.

Andover has one of the oldest public school systems in America, dating back to the mandate by the great and general court in 1647 that all townships with a population over 100 people must provide for a schoolteacher. The first public schoolhouse in Andover was constructed in 1700. Private education has also been a long-standing tradition in Andover. In 1778, Samuel Phillips founded Phillips Academy, a private preparatory school that has gone on to be the alma mater of presidents, Supreme Court justices, authors, inventors, Medal of Honor recipients, and other prominent figures. In 1829, Abbot Academy for Girls, the first private school for girls in America, was founded. Abbot and Phillips academies merged in 1973. Andover was also home to the Andover Theological Seminary, founded in 1808. Originally envisioned as a school within the greater organization of Phillips Academy, the number of students pursuing education in theology and divinity training was so large that it was incorporated as a separate institution. The theological academy moved to Cambridge in 1906. The printing of several important religious texts in the early 19th century by the Andover Press also helped to establish Andover's reputation as a bastion of critical thought. The first books in America to be printed in Hebrew and Greek were printed in Andover in 1813. Noted early American printers, such as Timothy Flagg, established printing companies in Andover that became world famous.

Andover is rightfully proud of its early and ardent involvement in the abolitionist movement. A riot broke out at Phillips Academy in 1835 over the issue of slavery. Believed to have been a conflict between students from free and slave-holding states, the melee resulted in the expulsion of 50 students from Phillips Academy and the theological seminary. In 1846, members of the West and South Parish Churches who felt the congregations had not been sufficiently vocal in opposition to slavery formed the Free Christian Church. Several local residents aided escaped slaves on the Underground Railroad. Wagon maker William Poor built wagons with hidden compartments used to smuggle escaped slaves. Most famously, author Harriet Beecher Stowe moved to Andover in 1852, just as *Uncle Tom's Cabin* was published in novel form for the first time. While her husband taught at the theological seminary, Stowe received such famous visitors as Sojourner Truth and Frederick Douglass. Douglass also delivered a rousing speech against slavery in Andover in 1853.

In 1855, after tremendous population growth and many years of consideration, Andover was split into two separate towns. The area nearer to the older North Parish Church became North Andover, while the larger section, centered on South Parish Church, retained the name Andover. Even before the establishment of north and south parishes in 1709, the intersection of Main, Elm, and Central Streets, better known as Elm Square, began to develop as a crossroads of commerce and travel. Conveniently located along the highly traveled Essex Turnpike (now Route 28), near both the South Parish and First Baptist Churches and within easy walking distance of the Boston and Maine Railroad train station, the area became the true center of the "new" Andover with the construction of the Town House in 1858. This area's status as nexus of the community was further cemented by the construction of Memorial Hall Library in 1871.

Following the attack on Fort Sumter by Confederate forces, some 500 Andover men volunteered to defend the Union. Over the course of the Civil War, nearly 600 men from Andover volunteered, more than filling Andover's expected quota of recruits, and some served for more than four years. Andover's proud veterans of the war, organized as the GAR (Grand Army of the Republic), could be seen in parades and patriotic events for decades to follow.

The mill industry continued to grow and increase Andover's stature and wealth in the later 19th century. The introduction of the trolley allowed increasing numbers of workers to travel ever greater distances to work and home. In addition to wool and flax, Andover produced rubber, precision tools, and fine brass, bronze, and metal works during this time. As the 20th century dawned, Andover began a subtle transition from agrarian community to manufacturing town. The existing railroad connections, the introduction of the automobile, and the expansion of trolley lines made Andover a center of both business and leisure activity for the region. The center of town developed in response to this economic growth with the construction of large commercial blocks along Main Street, like the Musgrove Building in 1895 and the Barnard Block in 1910.

The story of Andover's textile industry culminates with the story of William Wood. Born to a Portuguese immigrant family, Wood worked his way up through the Ayer Textile Company, eventually assuming management of the mill and even marrying Frederick Ayer's daughter Ellen in 1888. Wood consolidated the company holdings, expanded production, and took over several other small textile companies, eventually forming the American Woolen Company. Under Wood's leadership, the American Woolen Company became the largest textile manufacturing company in the world at the time. Over the course of both world wars, Wood's company provided most of the army blankets used by millions of soldiers.

Wood's most prominent contribution to Andover is doubtlessly Shawsheen Village, built at the north end of Andover in the area formerly known as Frye Village. Wood decided to centralize his textile company workforce by building a community for his administrative and executive employees in Andover, most of who worked and resided near the company headquarters in Boston, far from the mills and factories. Wood created two neighborhoods, "white Shawsheen" (named for the white wooden frame houses) for middle-management employees, and "brick Shawsheen" for the executive staff. Wood rearranged and moved entire streets and houses

to achieve his vision of a self-contained company town. Despite the rising popularity of the automobile at the time, almost no home in Shawsheen Village had a garage. Both neighborhoods had a community garage for automobiles, with drivers who would deliver residents to their cars in the morning and return them home at night. In addition, Wood's model community had its own pharmacy, post office, laundry, dairy, bowling alley, track and field, parkland, dance hall, and even a hotel, and even provided temporary offices for visiting textile buyers.

Andover was active during both world wars. Over 350 men volunteered for active service in World War I in 1917 and 100 more the next year. Phillips Academy initiated a military-training regimen for students. Two Andover sisters, Marjorie and Helen Davies, were among the first army nurses sent to tend to wounded soldiers and then to deal with the great influenza outbreak that followed the war in 1918 and 1919. The epidemic affected some 1,500 people in Andover, a town of only 8,000. Andover recorded 25 deaths attributed to the flu, including Wood's daughter, Irene.

While over 1,700 Andoverites enlisted in the armed forces during World War II, civilians also did their part with rationing, blackouts, and scrap-metal drives. The Civil War–era cannons that had long decorated the front of Memorial Hall Library were melted down to serve in another conflict. War games were planned for the streets of Andover and Ballardvale, with regular army testing the skills of the National Guard units by enacting an invasion by air over Cape Ann, but the exercise was called off at the last minute. Following the war, many of the military contracts that sustained the textile industry ended, and many of the businesses, including the American Woolen Company, closed their Andover facilities.

The construction of Interstates 93 and 495 through Andover changed the community's identity again. Developed during the postwar golden age of automobile travel, construction of the highways favored commuting convenience over any type of historical or community preservation. The highway plans both ran though neighborhoods and paved over farms that had existed for centuries. By providing quick access to Boston, the highways also changed Andover from a predominantly rural community to a bedroom community of urban workers but suburban residents. The highways also helped encourage economic development in Andover. While much of the old agrarian and textile economy was in decline by the middle of the 20th century, ease of access created new business opportunities. Institutions like Raytheon, Gillette, Hewlett Packard, and the Internal Revenue Service established large facilities in Andover on former farmland. Many other farms were obliterated as the postwar need for housing continued to grow.

A series of photographers have helped document Andover's history for over a century. Charles Newman maintained a photography business in Andover from the 1880s until the 1930s and left thousands of images, including many of schoolchildren, a favorite subject. Donald Look continued the tradition in the 1940s and 1950s. Richard Graber's work in the 1960s captured an Andover in transition and left a powerful record of a turbulent time. Today several photographers have made Andover and its people their principal subjects. These images give an almost unbroken photographic record of the changes and events that shaped the town, the nation, and the world at large.

The photographs, images, and documents in this book tell of events both epic and small and of people both great and common. Yet the images here, in this limited space, tell only a small portion of the whole story of Andover. Perhaps they will inspire the reader to seek out more of that history and to discover the story of Andover over 350 years.

One

EARLY YEARS

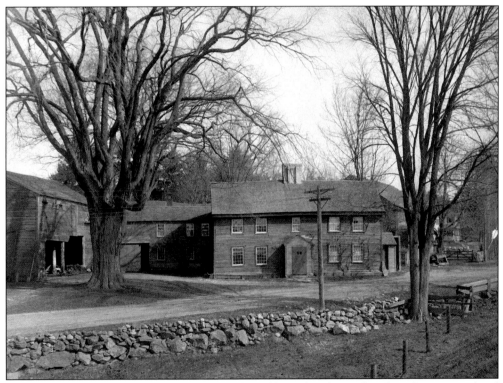

Reputed to have been built around 1685, the Abbott farmhouse has long been considered the oldest building in Andover, although recent investigation may belie that claim. It was constructed by carpenter Benjamin Abbott, son of one of the founders of Andover and one of the accusers in the 1692 witch hysteria. It has served as a family farm and a teahouse and is now a private residence.

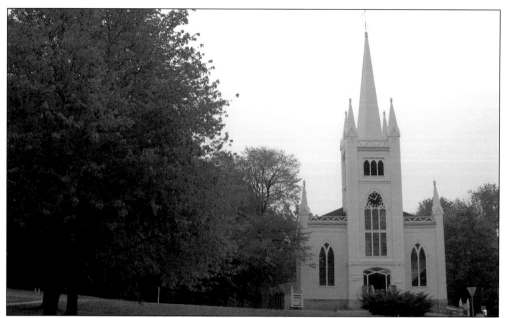

Founded by the first families who migrated to Andover, what is now known as the First Parish Church was established in 1644. In 1692, minister Francis Dane was a vocal opponent of the witch trials. His public criticism of the general court's methods of determining guilt was instrumental in ending the trials. The 1836 building shown here is the fifth church built for the congregation.

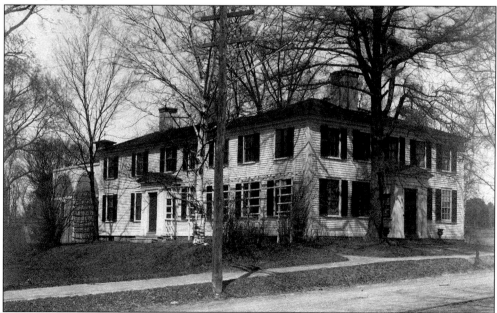

In 1776, schoolmaster Isaac Abbott opened a tavern and inn at his home at what is now 70 Elm Street. In 1789, Pres. George Washington visited Andover. Local lore tells that while Washington had breakfast at the tavern, Abbott's daughter Priscilla mended his torn glove. Washington rewarded the young girl with a kiss on the cheek. The age of the house is uncertain, but it is believed to date from the late 17th century.

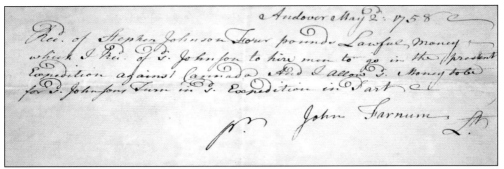

This receipt reads, in part, "Andover, May 2, 1758 Rec'[eived] of Stephen Johnson Four Pounds Lawful Money which I Rec[eived] of S. Johnson to hire men to go in the present Expedition against Canada." Johnson fought at the battle of Fort William Henry in 1757 during the French and Indian War and would have gladly participated in a counteroffensive. The incident is believed to have inspired events depicted in James Fenimore Cooper's *Last of the Mohicans*.

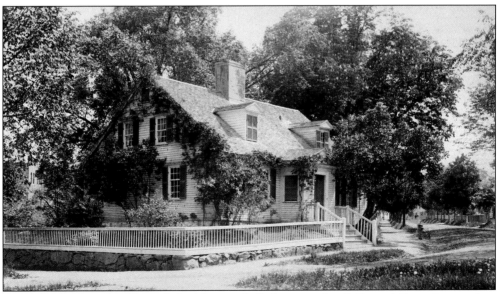

In 1825, John Kneeland hosted the Marquis de Lafayette at his 2 Central Street home when Lafayette stopped in Andover on his tour of the United States. Constructed in 1784, the home was occupied by many families and used as a tearoom in the early 1900s. The gardens surrounding the building are the source of the tearoom's name, Rose Cottage, which has persisted long after the business. The building is again a private residence.

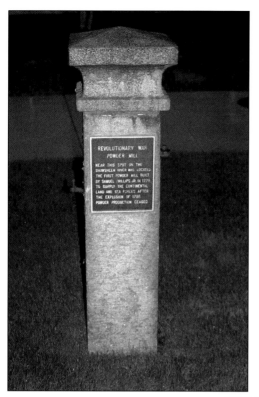

Built to provide gunpowder to the Continental army during the American Revolution, Samuel Phillips's powder mill was a dangerous operation. Three explosions over the years killed five men in total. This monument marks the approximate site of the powder mill, which ceased production after the last explosion in 1796. Soon after, Phillips switched to producing paper and ultimately sold the mill in 1807.

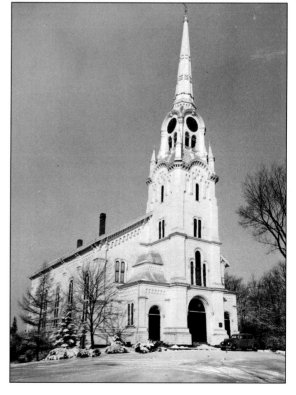

Andover was divided into two parishes in 1709 to accommodate the population in the southern part of town and the prohibitive travel distance to reach what is now First Parish Church in North Andover for weekly services. The first South Parish Church meetinghouse was built in 1711. The current church, seen here, was built in 1861 and is the fourth house of worship on or near this site.

The Shawsheen River cuts through all parts of Andover. The name Shawsheen means "great spring" in Pennacook. The Shawsheen River has played a critical part in the development of Andover, as mills were built to take advantage of the strong current.

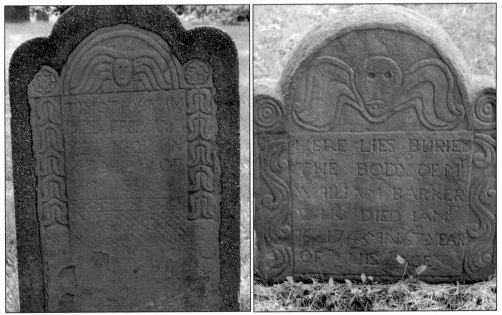

These headstones are those of William Barker, accused of witchcraft, and Timothy Swan, an accuser. Although neighboring Salem is better known for its involvement in the witchcraft panic that gripped the area in 1692, Andover saw more accusations and arrests than any other town. In all, more than 40 Andover citizens were accused, 8 were tried and convicted, and 3 were executed.

This deed of sale, dated August 14, 1694, passed between some of the most prominent figures in 17th-century Andover. Justice of the peace Dudley Bradstreet, who signed over 40 warrants accusing citizens of witchcraft, sold Benjamin Abbott, one of the accusers, several plots of land. Interestingly, it is witnessed by Thomas Barnard and Benjamin Stevens, who signed petitions to end the trials and wrote letters supporting the accused.

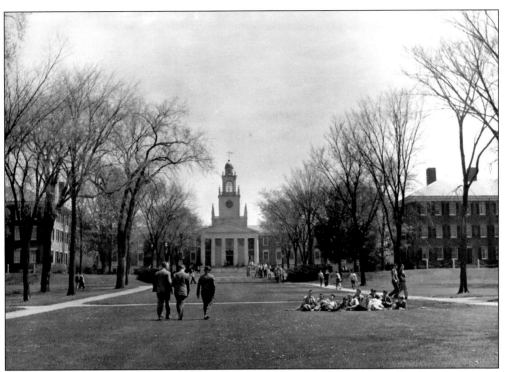

Established by Samuel Phillips Jr., Phillips Academy is the oldest private school in the United States. Known for its academic excellence, the school has maintained a policy of admitting "youth from every quarter," regardless of social standing, since its founding in 1778.

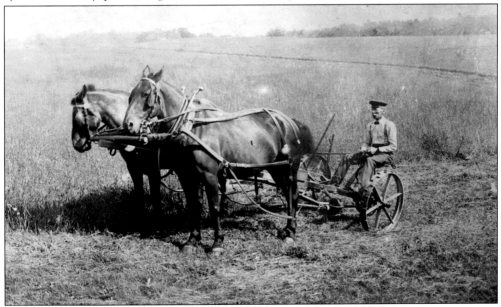

One of the largest and oldest farms in Andover, Shattuck Farm was founded by Thomas Shattuck in 1728 in west Andover, close to the Merrimac River. Archaeological excavations have indicated that Shattuck Farm has been the site of human occupation for several thousand years. In the 1950s, large portions of Shattuck farmland were used to create Route 93.

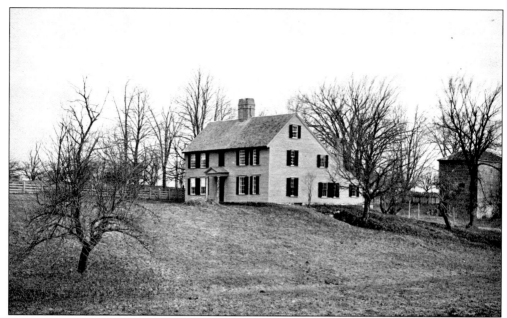

This house was long believed to be Simon and Anne Bradstreet's original home and the first structure built on the site. Research revealed that a 1707 fire destroyed the original building. In 1714, the property was sold by Dudley Bradstreet to Thomas Barnard, who also purchased the ruins of the old house and possibly incorporated elements of the original building into the new one.

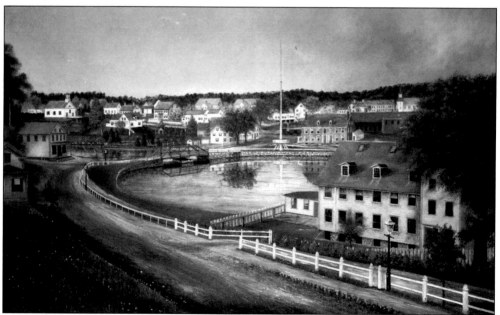

In the 18th century, John Ballard settled in a hilled area south of central Andover along the Shawsheen River. The area became known as Ballard's Vale, later shortened to Ballard Vale and then Ballardvale. Ballard built several saw- and gristmills along the Shawsheen River, beginning Ballardvale's long tradition of river-powered industry. This detailed painting, *Ballardvale in 1881*, was done by local artist Bancroft Haynes, who had no formal artistic training.

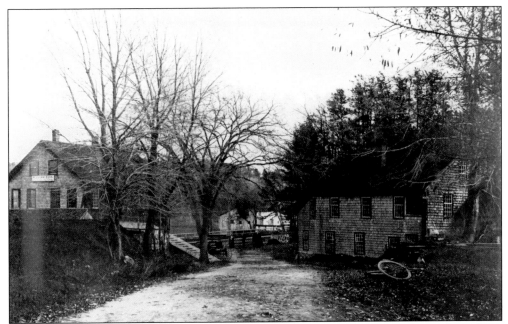

In the 19th century, William Poor and his family ran a successful wagon shop in north Andover (not to be confused with North Andover) in what was then known as Frye Village. Poor was an ardent abolitionist and conductor on the Underground Railroad. Poor not only took in escaped slaves but also built wagons with hidden compartments designed to smuggle them to safety.

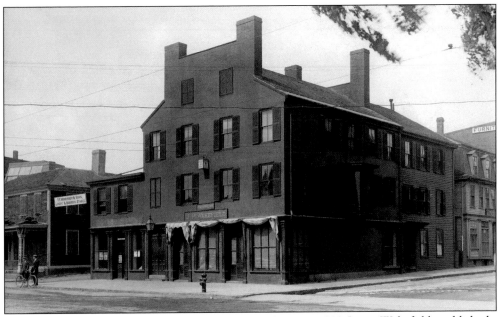

Capt. Benjamin Abbott's home was built at 12 Main Street in 1800. James Wakefield established a provisioners store there around 1850, modifying the building by raising it and adding a storefront to the new ground level. Wakefield's provided dry goods, dairy, and meats. Wakefield visited his customers in his meat wagon, cutting sides of meat to customers' specifications in front of their homes.

Located just to the north of the old town center, Lake Cochichewick has been a critical resource since before the Colonial era. Native American tribes hunted and fished along the lake. The lake was a spawning ground for alewife, a local fish that was a dietary staple. Settlers followed, creating grazing land along the shore. Today the lake is North Andover's principal water supply.

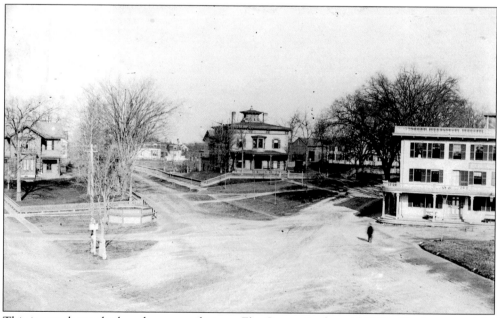

This image shows the broad expanse that was Elm Square in the mid-1800s. To the upper right is the Elm House, now the site of the Musgrove Building. In the center is the Flint Mansion, home of the Square and Compass Club. On the far left is the Punchard/Barnard Mansion, now Enterprise Bank, and the only one of these buildings still standing.

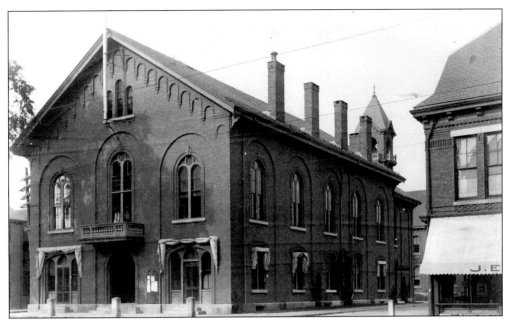

Built in 1858, the Town House (also known as town hall) was built to accommodate the administrative needs of the town of Andover. Government offices and police were found on the first floor, and the upper floor held an auditorium for meetings or large functions. This image, one of the oldest known to exist, dates from the early 1880s. The old firehouse tower can be seen to the rear.

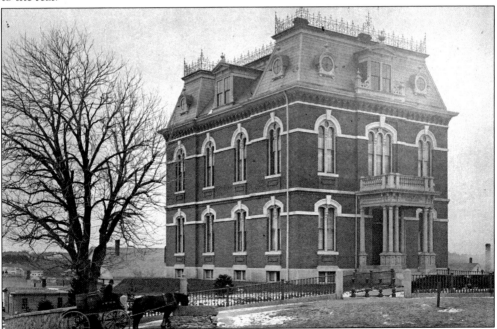

When constructed in 1872, Memorial Hall Library had a decidedly Gothic Victorian style, as seen in this image from the same year. The iron fence was meant to keep wandering cattle off the lawn. Note the granite water trough. The roofline and details were modified to a more neoclassical/Georgian design when the building was expanded in 1927.

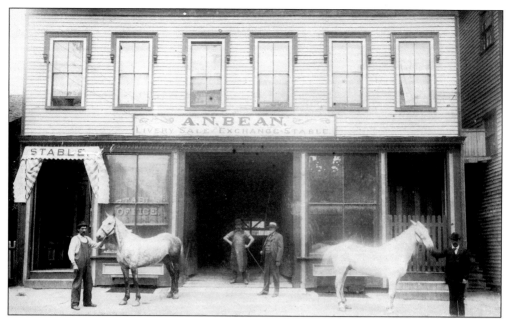

This image shows A. N. Bean's livery on Park Street in the late 19th century. A horse and carriage could be hired for a day trip to Haggett's Pond or quick run to the train station in the same way a taxi or rented car is hired today. Bean sold the livery to W. H. Higgins in the late 1890s. A bowling alley later occupied the site for several decades until being demolished in the 1990s.

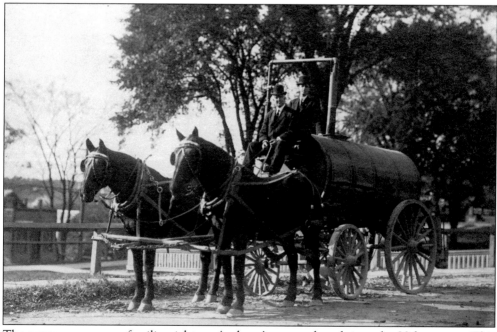

The water wagon was a familiar sight on Andover's unpaved roads into the 20th century. This horse-drawn wagon continually sprayed the dirt roads with a fine mist to keep dust down. While the roads have been paved since the 1930s, the standpipe where the wagon refilled its tank still exists at the corner of Park and Whittier Streets.

Two

FACES OF ANDOVER

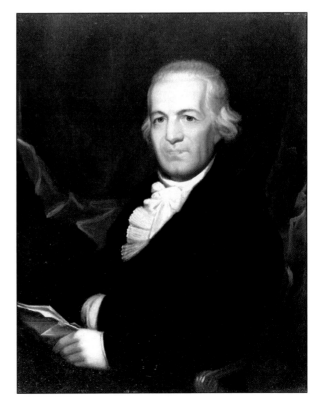

Samuel Osgood was a direct
descendant of John Osgood, one
of the first settlers of Andover
and a pivotal figure during the
American Revolution. He led a
company of soldiers at the battle
of Lexington and Concord and
represented Massachusetts in the
Continental Congress from 1776 to
1780 and the Massachusetts senate
from 1780 to 1785. He served as
the first postmaster general of the
United States from 1789 to 1791.
(Courtesy of the North Andover
Historical Society.)

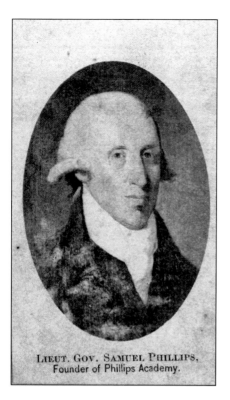

LIEUT. GOV. SAMUEL PHILLIPS,
Founder of Phillips Academy.

A personal friend of George Washington, Samuel Phillips was a prominent figure in Andover in the late 18th century. Not only was he the founder of Phillips Academy but also a town selectman and the owner of the gunpowder mill that provided ammunition for Washington's army.

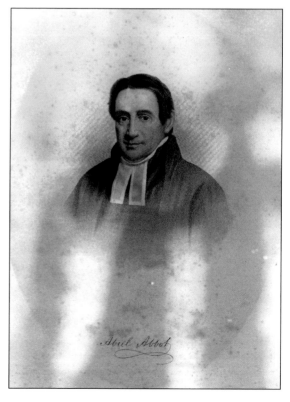

Born in 1765, Abiel Abbot was a noted Andover historian and author. His book, *History of Andover From Its Settlement to 1829*, is still one of the most detailed and informative books on Andover's first 200 years. He died in 1859.

Born in Lincolnshire, England, Simon Bradstreet came to America in 1630 as an officer of the Massachusetts Bay Company, a position he retained for 49 years. A prominent figure in Andover's early history, he also served as governor twice, first from 1679 to 1686 and again from 1689 to 1692, interrupted by Sir Edmond Andros's disastrous attempt to consolidate the New England colonies into the New England Dominion. (Courtesy of the North Andover Historical Society.)

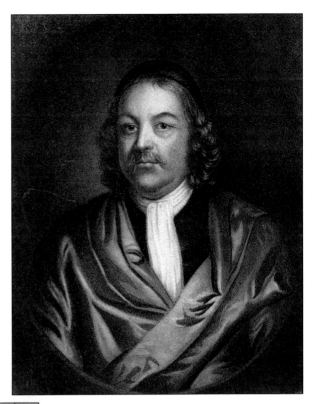

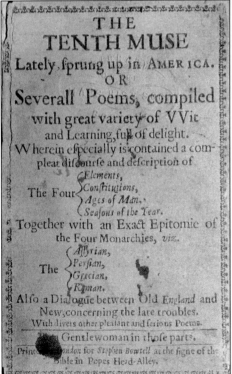

Born Anne Dudley in 1616 in Northampton, England, daughter of another Colonial governor, Thomas Dudley, Bradstreet's wife was famous in her own right as an accomplished author and poet. Her first book, *The Tenth Muse* (*Lately Sprung up in America*), was published in 1650. It was the first book of poetry written in the American colonies.

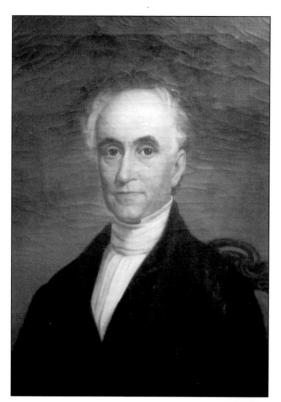

Amos Blanchard was a deacon of South Parish Church and a cashier at the Andover Savings Bank. In the early 19th century, the bank cashier was an extremely important position, only slightly below bank manager. In 1818, Blanchard purchased land between South Parish Church and Phillips Academy on the Essex Turnpike (now Main Street). He built a barn on the site that same year and a large home in 1819.

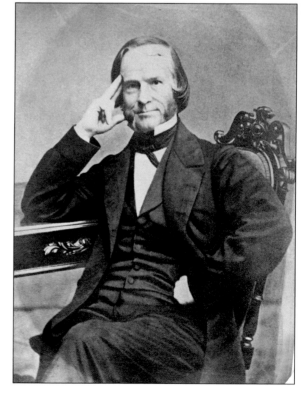

Amos Blanchard Jr. also resided at the house his father built with his parents and brother and inherited the property after his father's death in 1847. Following in his father's religious footsteps, he became a minister. Both Blanchards took in boarders from Phillips Academy and the theological seminary, sometimes housing 4 or 6 students to a room and as many as 15 boarders at a time in a house with only four bedrooms.

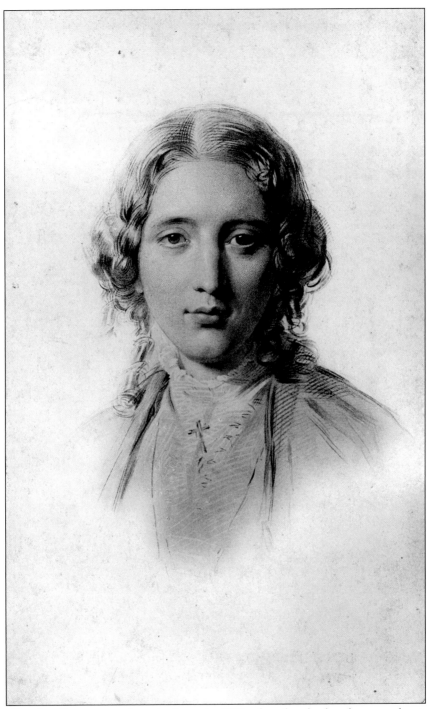

Harriet Beecher Stowe moved to Andover in 1852 when her husband accepted a teaching position at the Andover Theological Seminary. That same year, her serialized story, *Uncle Tom's Cabin,* was first published as a complete novel. Many famous figures in the antislavery movement visited Stowe in Andover, including Sojourner Truth and Frederick Douglass. Stowe's house still exists on Bartlet Street. She her husband are buried in Andover at the academy chapel.

Allen Hinton was a former slave who moved to Andover in 1864. While working as a waiter at the theological seminary, Hinton began a home-operated ice-cream business, possibly the first one in New England. Initially the only flavors were vanilla and lemon, but the business was a runaway success, selling fresh ice cream twice a week to Andoverites as well as the seminary and academy students.

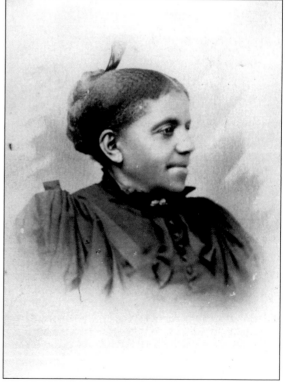

Mary Jane Palmer was a widow who married Hinton in 1867. She first worked as a cook and took in laundry from Phillips Academy students. Once the ice-cream business was a success, they bought a farm on Hidden Road in 1901, building a pavilion for customers and later a full shop. The ice-cream shop became so popular that it attracted customers from as far away as Boston.

This 1865 image was taken in New York by the two men in the image, who were on their way home to Andover from service in the Civil War. Ballard Holt (standing) and Walter Allen were both members of long-established Andover families. Over 600 Andover men served in the Civil War.

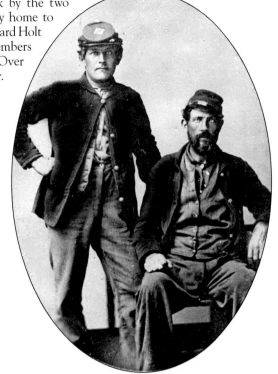

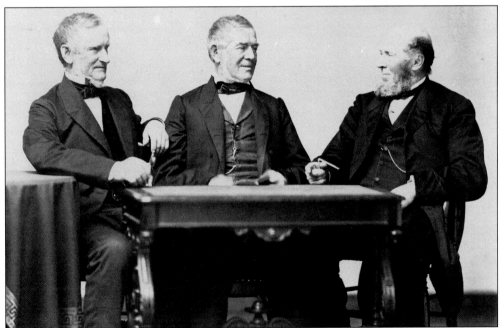

Partners in the Smith and Dove mill, Peter Smith (left), John Dove (center), and John Smith (right) were immigrants from Brechin, Scotland. Dedicated abolitionists, the Smith brothers funded antislavery newsletters and societies and aided in the financing of several community buildings and projects, including the construction of the Free Christian Church in Andover in 1834.

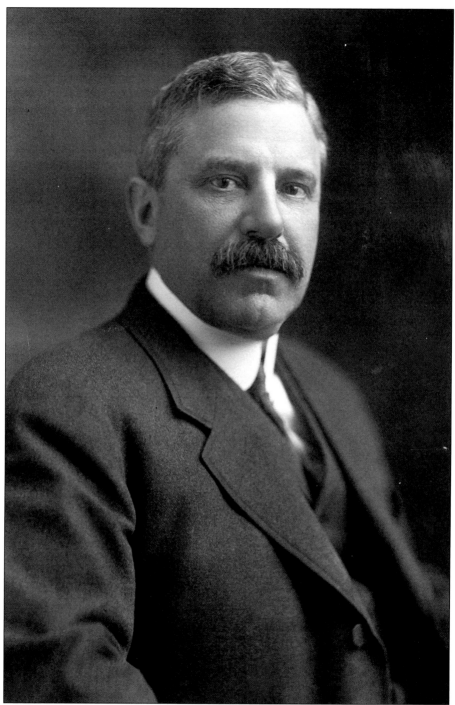

William Wood was born in 1858, the son of Portuguese immigrants. When Wood was 12, his father died, and he was forced to find work in a textile mill. By 1900, Wood was president of the American Woolen Company, the world's largest textile manufacturer. After the tragic deaths of his daughter Irene in 1918 and his son William in 1922, and suffering a debilitating stroke in 1924, Wood committed suicide in 1926.

The Goldsmith family lived in Andover for centuries and owned large plots of farm- and woodlands. William Goldsmith, seen here, was a man of many talents and interests. He served as school principal, selectman, postmaster, and park commissioner. Goldsmith is perhaps best remembered for his tireless work with AVIS (Andover Village Improvement Society) to protect and conserve natural resources throughout Andover and make the woodlands available to everyone.

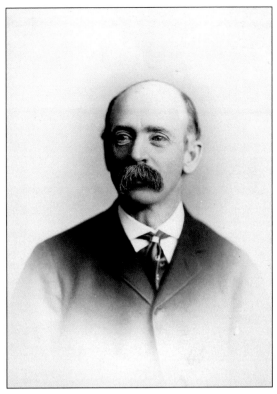

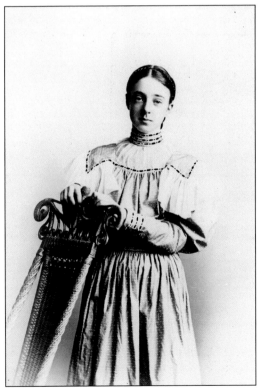

This placid image of Goldsmith's daughter Bessie as a young girl belies the community leader, staunch environmental advocate, and flamboyant character she became in later years. Bessie followed in her father's footsteps with AVIS, helping to protect and preserve Andover's woods and parklands. She was also an economics teacher, a columnist for the *Andover Townsman*, and served as Andover's first female police officer.

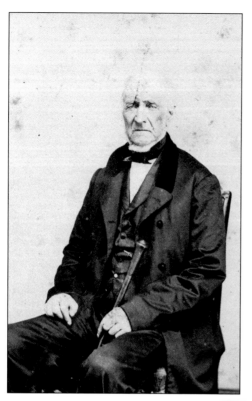

Born in 1782, Joshua Ballard was the son of Hezekiah Ballard and a member of one of Andover's oldest families. Joshua inherited significant amounts of property from his father and operated the Ballard Tavern, an inn for travelers along the Essex Turnpike road between Boston, Andover, and Methuen. Early land rights often meant a family stayed prosperous for many generations. This image was taken shortly before his death in 1859.

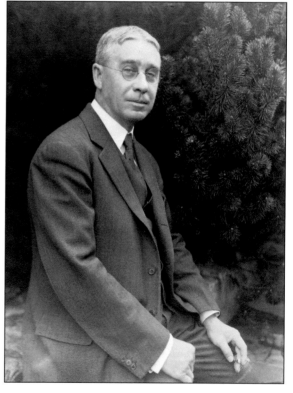

Addison Le Boutillier worked as an architect, sketch artist, modeler, engraver, and painter. His work with decorative tiles is considered his best and commands high prices at auction. His architectural legacy can be found across Andover in detail work on the facade of Shawsheen School and several private homes on Orchard Street. Several Le Boutillier pieces are included in the permanent collection of the Boston Museum of Fine Arts.

Carl Elander was a tailor and proprietor of the popular Elander's Men's Clothing Store, later known as Elander and Swanton's. As the business grew through the first half of the 20th century, the shop operated in an ever-increasing storefront along Main Street. In 1959, partner Stanley Swanton bought out Elander, operating independently until 1967. The store closed in 1973.

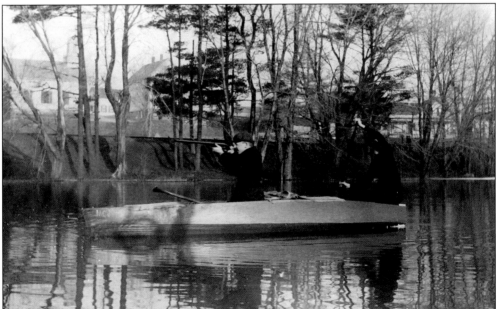

An avid sportsman, Charles Davies was an expert marksman. It was on the grounds of his hunting dog kennels that the sport of skeet shooting was first developed and perfected by Davies and his friend William H. Foster, a wildlife artist and writer, as a means to improve their skill shooting game in flight. Skeet shooting became so popular it was eventually included as an Olympic sport.

Charles H. Newman established a photography studio in Andover in the 1880s, just as commercial photography was becoming popular. Over the next 50 years, Newman captured many different images of Andover, from the 250th anniversary celebrations of the town's founding in 1896 to personal portraits and class photographs. Over 5,000 different images taken by Newman are in the archives of the Andover Historical Society, and several are used in this book.

Continuing the long line of Andover photographers, Richard Graber came to Andover in 1960, taking over Donald Look's studio in the Musgrove Building. The official photographer for Phillips Academy (as was Newman), Graber often found his office a gathering spot for local teenagers. His images of Andover in the 1960s capture a time of transition and change.

Armenian immigrants Rose and Sarkis Colombosian came to America in 1922. The Colombosian family operated a cow and goat dairy for many years. Working from the kitchen of her Andover home, Rose is credited with using an old family recipe to produce the first yogurt commercially sold in America. Although no longer a family-owned business, Colombo yogurt is a nationally recognized brand.

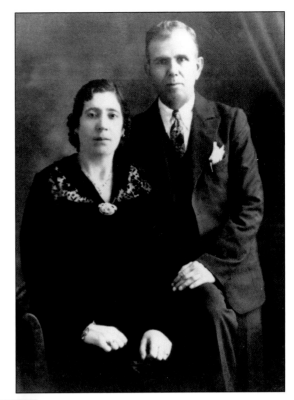

Joshua Miner was a physical education instructor, coach, and housemaster at Phillips Academy. While teaching in Scotland after World War II, Miner met Kurt Hahn, founder of the Outward Bound program, which teaches outdoorsmanship, team building, and self-reliance to special-needs or at-risk youth. Miner brought the program to America in 1961, and over 750,000 people have participated. Miner retired as dean of admission at Phillips Academy in 1985 and passed away in 2002.

A noted intellectual, linguist, author, and translator, Stephen Byington was born in Vermont but lived on High Street in Ballardvale until his death in 1957. Byington was fluent in at least a dozen languages. He spent over 60 years translating the Bible from various original texts into contemporary language. His version, *The Bible in Living English*, was published posthumously in 1972 and remained in print for many years.

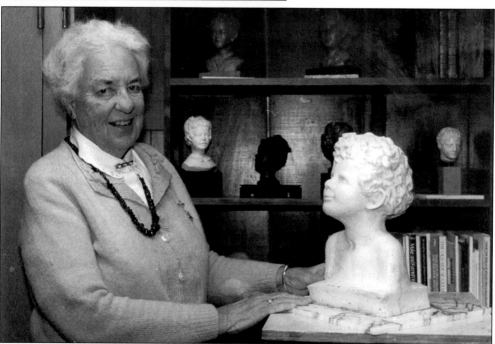

Beverly Darling was well known for her sculpture work. While she created busts and sculpture in many styles and of various subjects, she was best known for her busts of children. Darling's passing in 2007 merited a full obituary article in the *Boston Globe*.

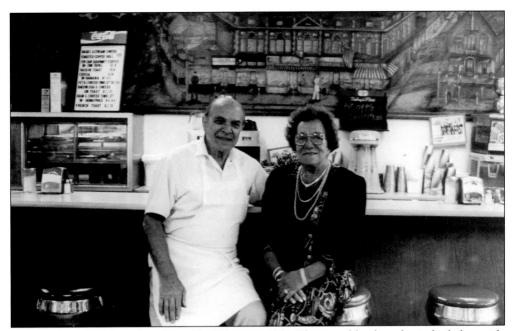

Tom and Stella Koravos bought Ford's Bakery in 1954. They quickly phased out the bakery side of the coffee shop in favor of more table space, creating an Andover institution that lasted for 40 years. Town selectmen congregated there so often, it was said that more town business was done in Ford's than in the town offices.

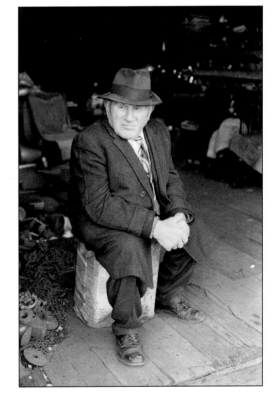

A fixture of downtown Andover from the 1950s to the 1980s, Morris (Mo) Krinky's salvage yard on Park Street is fondly remembered by many Andoverites as a reminder of a simpler time. Rain or shine, Krinsky could be found every day in his folding chair in the front doorway of the salvage yard garage.

Known as "Mr. Town Meeting," Jim Doherty has been a fixture in the town government of Andover for generations. Starting as recreation committee member in 1956, he first assumed the role of town meeting moderator in 1978. He retained the post for the next 29 years.

Three

LANDMARKS PAST
AND PRESENT

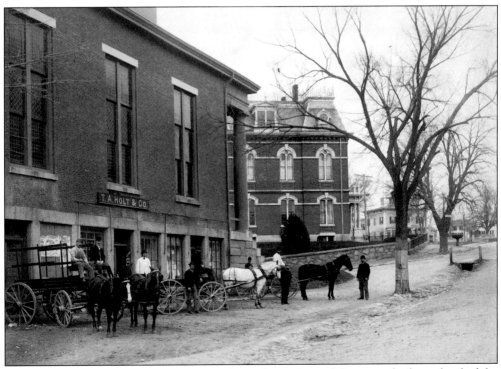

The home of T. A. Holt's supply store was located at 7 Central Street in the lower level of the Andover Baptist Church for almost a century. The church originally leased the space to Holt to defray construction costs.

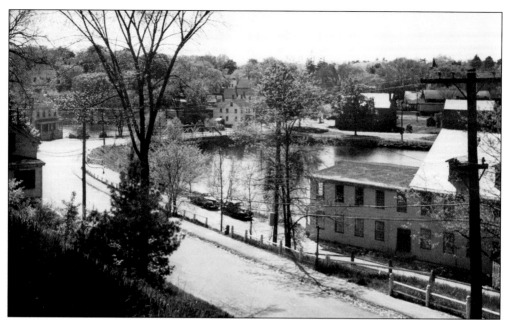

Ballardvale is a village situated within the town of Andover that had its own schools, post office, and firehouse. Timothy Ballard built the first mill at the start of the 18th century, but the mill built by John Marland on the site in 1836 became the centerpiece of a mill and manufacturing complex that still exists today. Today Ballardvale is Andover's only recognized national historic district.

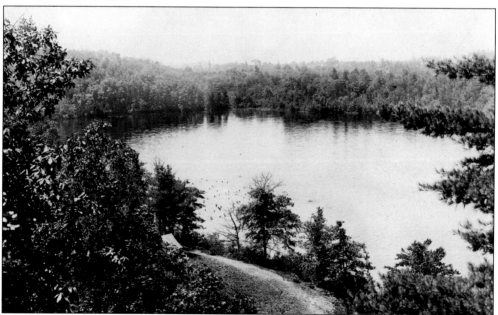

Pompey (Pomp) Lovejoy was a freed slave who resided in Andover. Lovejoy and his wife, Rose, lived in a small cabin alongside the pond that bears his name. They were well known for providing homemade ginger beer and "election day cake" for voters every election day, although neither of them was ever allowed to vote. His birthday was unknown, but Lovejoy supposedly lived to be over 100 years old.

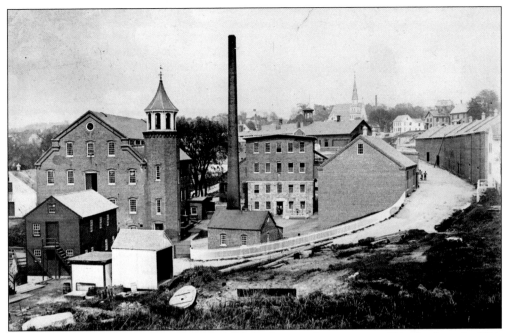

Brothers Abel and Pascal Abbott constructed the first textile spinning mill in Andover in 1814. Abbott Village developed around the factory and included homes, schools, and churches. The Abbotts were bought out in 1837 by Peter and John Smith and John Dove, who greatly expanded both the community and mill complex.

FIELDSTONES BY SALLY BODWELL, ON HIGHWAY 28, ANDOVER, MASSACHUSETTS 5048

Now the site of Andover Montessori School, the farm founded by James Jaquith in 1840 was best known as the site of Fieldstone's restaurant, a popular Andover eatery in the early 20th century. The main dining room was situated in the original barn. In later years, the Jaquith farm served as the Andover Elks Club.

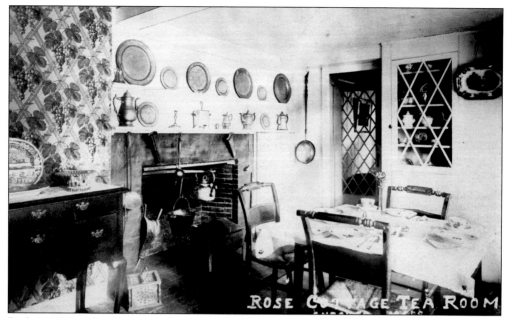

Built in 1784 and made famous by a visit from Revolutionary War hero the Marquis de Lafayette in 1825, Rose Cottage at 2 Chestnut Street has seen many tenants and owners. It only operated as a tearoom from 1910 to 1912, but the name and legacy stuck. This postcard image shows one of the interior sitting rooms from about 1910.

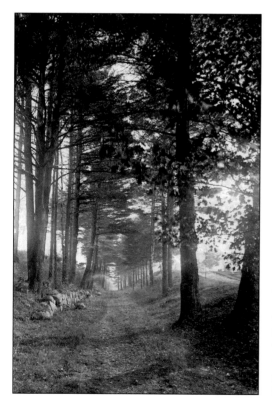

Built in the 1830s, the Andover and Wilmington Railroad followed a path through the heart of town before heading south to Ballardvale and Wilmington. The tracks ran through gardens and front yards and crossed Central Street at Chestnut Street close enough to throw sparks onto the roof and lawn of Rose Cottage. The tracks were removed in 1845. This image shows the train track's path through Spring Grove Cemetery sometime later.

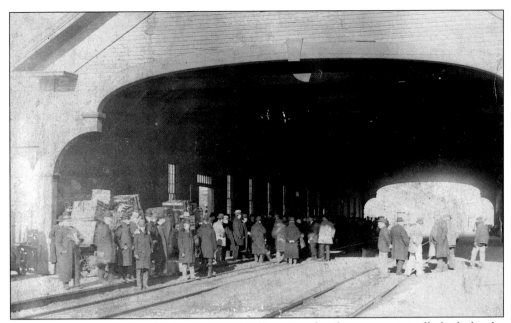

The railroad first came to Andover in 1834. This covered rail station, originally built for the Boston and Maine Railroad, was a scene of constant activity. By the late 1800s, rail travel between Andover and Boston was commonplace, giving rise to the first commuters and bringing large numbers of tourists to Andover for the first time. The station was demolished and replaced in 1905.

The Ballardvale firehouse was built in 1896 on the corner of Clark Road and Andover Street and is still in use today. The stub of the original bell tower, where the hoses were hung to dry, that overlooked the building remains on the left. The trucks housed at this location are custom built smaller than traditional fire and rescue vehicles in order to fit into the little building.

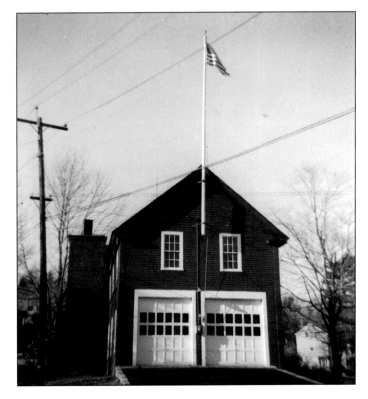

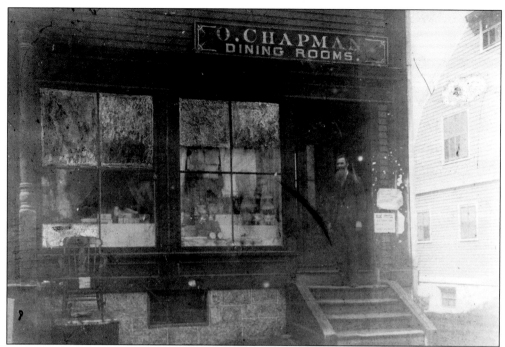

In the late 19th century, 127 Main Street was the site of Chapman's, or "Chap's" Restaurant, a popular spot for Phillips Academy students. Chapman's gave way to Doc's and later the Coffee Mill. Today the neighboring Andover Shop clothing store has expanded into the entire storefront.

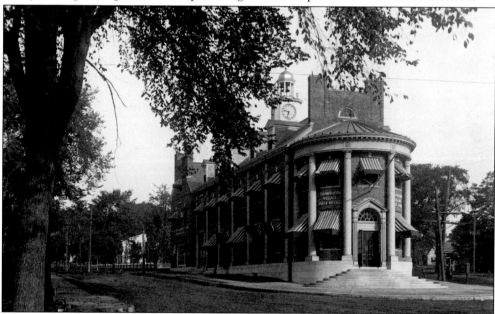

When William Wood developed Shawsheen Village in the 1920s, it included all the traditional public buildings of a self-sufficient village, including such public facilities as a pharmacy, laundry, and power plant. This building at One Shawsheen Square was originally built as the Shawsheen Village post office and town market. It was later occupied by the Merrimac and Cambridge Mutual Insurance Company, forerunner to the Andover Companies.

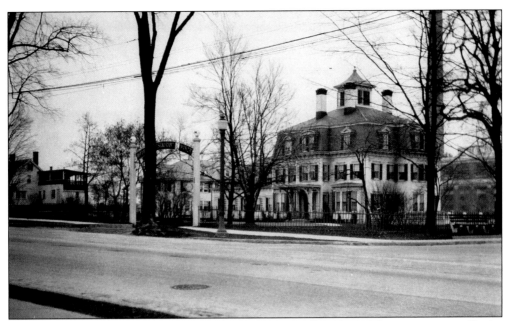

Shawsheen Village was in many ways a company town. Shawsheen Manor was originally the estate of 19th-century mill owner John Smith. It was remodeled and expanded to serve as a hotel for businessmen who traveled to Andover to deal with the Andover Woolen Company. For vendors, agents, and salesmen who needed to stay in close contact with the home office, suites with telephones were available for hire across the street.

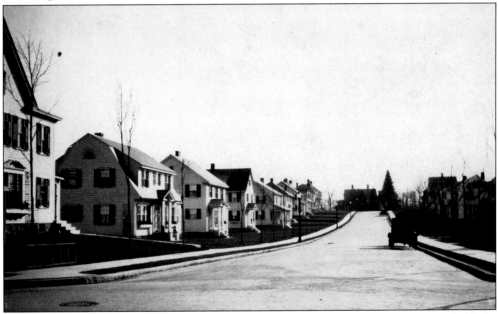

Shawsheen Village's residential neighborhoods were split into two sections, distinguishable by the architecture. "Brick Shawsheen," built to the west of Main Street, was meant for American Woolen Company's executives. "White Shawsheen's" wooden frame homes, built to the east of Main Street, were intended for middle management. This view down Carisbrooke Street in "white Shawsheen" was taken in the early 1920s.

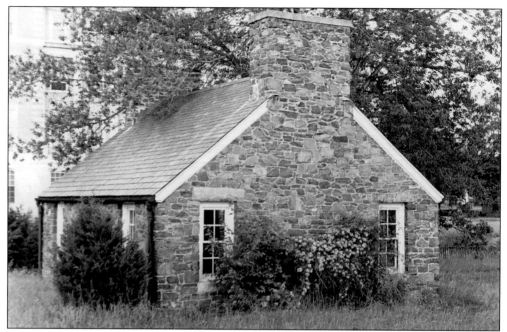

Often mistaken for a remnant of Andover's Colonial past, this stone structure was built along with the rest of Shawsheen Village in the 1920s. It is a replica of a historic building William Wood saw at Valley Forge, Pennsylvania. In the past, it has been used as the headquarters for the Andover branch of the Boy's Club and a local polling place.

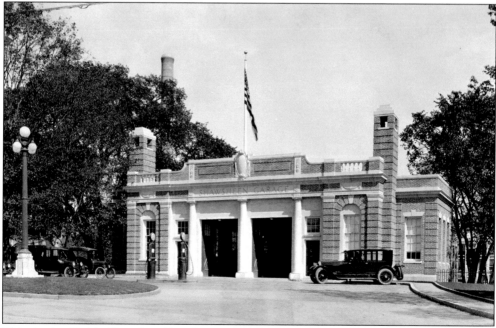

This is the "brick Shawsheen" parking garage on North Main Street, not long after its construction in the 1920s. Drivers were dispatched to residents homes with their cars and drove them home as well. A second garage was built on Haverhill Street for "white Shawsheen." Both buildings are used by Woodworth Motors today.

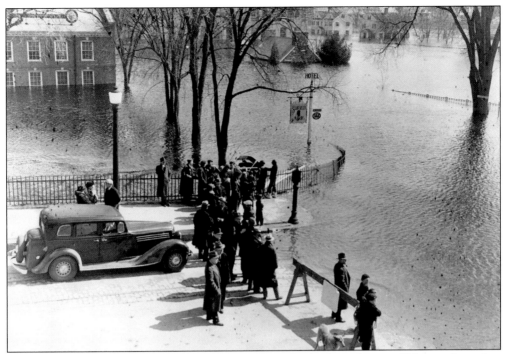

The Shawsheen River has been a source of prosperity for Andover for over 300 years, but it has been the source of disaster as well. In March 1936, heavy rains and an early spring thaw led to serious flooding throughout the area and the Shawsheen overflowing its banks. Shawsheen Village was one of the hardest-hit areas in the Merrimac Valley. Note the roof of the stone house from the previous page, just above the water.

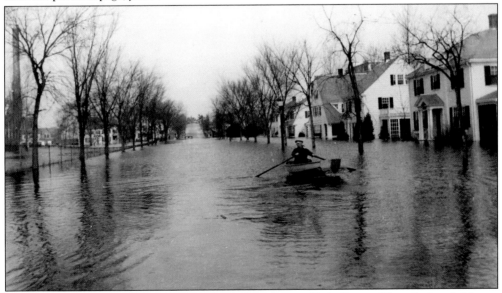

This image shows a solitary rower making his way up York Street. The playing fields are to the left. The March 15, 1936, flood caused widespread damage along North Main Street and in Shawsheen Village, with some families forced to enter their homes through second-story windows.

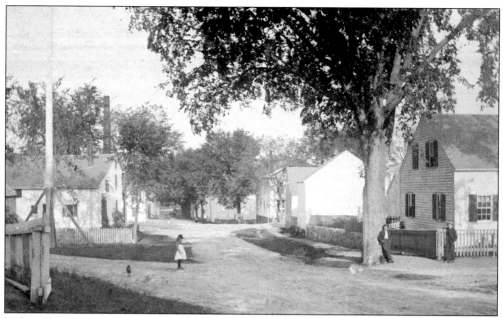

Before Shawsheen Village, there was Frye Village. Samuel Frye established a gristmill along the Shawsheen River in 1718, the first of many businesses in the area, including Poor's Wagon Shop and the Hardy Brush Company. This image, taken around 1890, shows the center of Frye Village looking east along Haverhill Street. The village meeting hall, just visible in the rear on the right, was moved to Balmoral Street in the early 1920s.

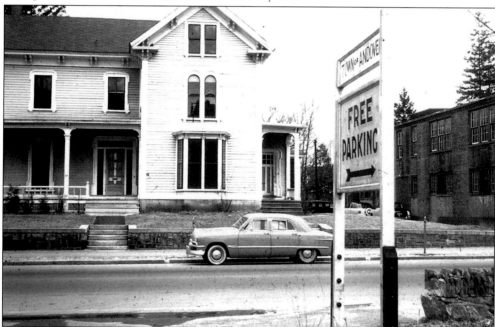

The house in the image at 84 Main Street was built in the late 1800s. A group of homes lie behind along the now-gone Main Street Terrace. The house and the street were demolished in 1955 to make room for a new bank. In the foreground is another reminder of Andover's past—free parking in the Main Street municipal lot.

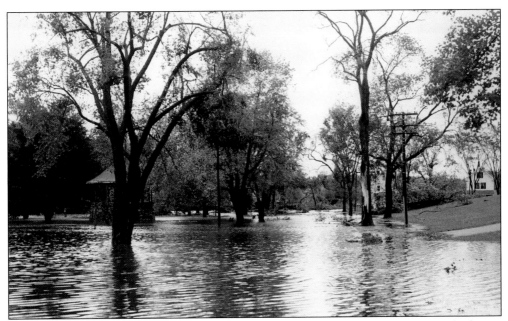

The Shawsheen River was not the only flood problem facing Andover. Roger's Brook, which runs through the center of town, has occasionally overrun its banks as well. This image from 1954 shows Central Park seen from Bartlet Street, completely flooded following a major hurricane. For reference, Punchard High School would be to the right of the image. Note the lonely island of the bandstand behind the tree.

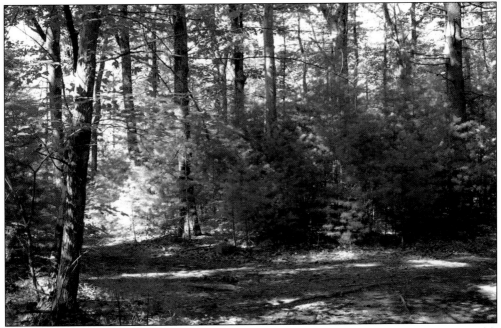

Harold Parker State Forest was farmland and lumber forest until 1916, when the Commonwealth of Massachusetts bought the land. The new state park, named for the recently deceased state parks commissioner, stretched between Andover, North Andover, and Middleton. It was also the site of several Civilian Conservation Corps public works projects during the Great Depression.

The Little Brown Jug on Lowell Street was a frequent hangout for Punchard High School students in the 1950s. Commonly referred to as "the jug," teens gathered for burgers and sodas after a football game or before a Friday night movie at the Andover Playhouse. The Little Brown Jug closed in the 1960s.

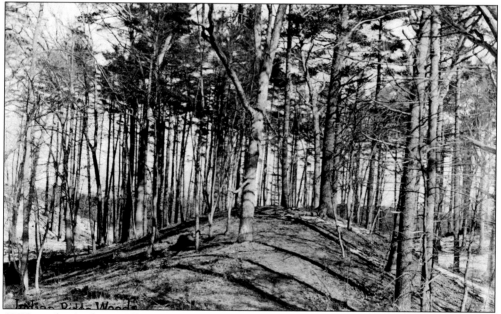

AVIS, or the Andover Village Improvement Society, the second-oldest land conservation group in America, was founded in 1894 by 30 citizens of Andover concerned with preserving and maintaining woodlands and nature trails throughout Andover. Today AVIS manages over 1,000 acres of land throughout the town. Indian Ridge Reservation, shown here, was added to AVIS land in 1915.

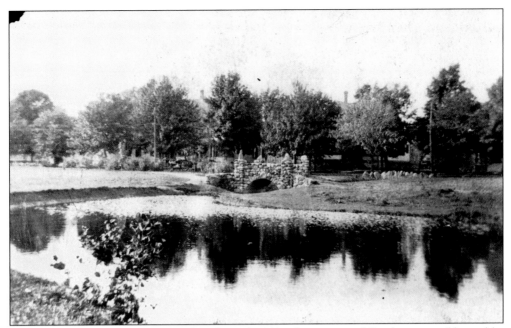

Roger's Brook ran through Central Park until 1968, when repeated flooding was addressed by diverting the brook below street level all the way to the Shawsheen River. This image, looking toward Chestnut Street, shows the brook in a serene moment in the 1920s. The bridge crossing the brook still stands in Central Park.

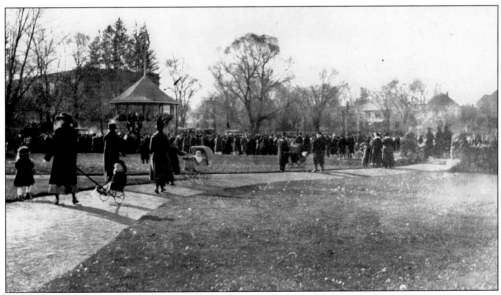

Also known as the town park, Andover Park, or simply "the park," the area at the corner of Bartlet and Chestnut Streets is officially named Central Park. This image shows a gathering in the park on a cold day around 1900. Note the wide-open spaces of the park lawn, now filled with trees.

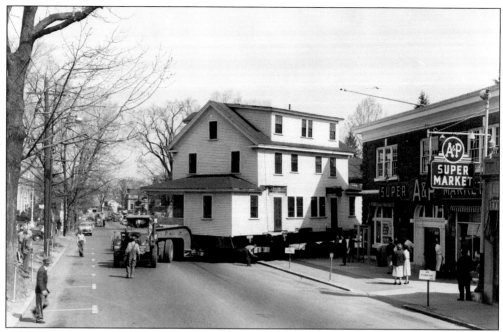

While many of Andover's landmark homes and buildings have been lost to time, some were saved from demolition by a challenging and cautious relocation from their original sites. The house in this undated image is being removed from Main Street Terrace, a street that no longer exists. In the foreground is the Andover A&P supermarket at 90 Main Street.

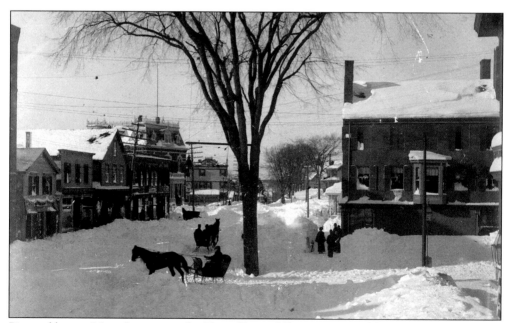

Pictured here is Main Street near the Town House following a major blizzard in February 1898. When weather like this occurred, sleds replaced horse-drawn wagons, and the trolley was not able to travel. Streets were cleared by hand shovels, and truckloads of snow were dumped into the Shawsheen River.

Four

BUSINESS AND INDUSTRY

In 1900, there were over 200 farms of various sorts in Andover. As of 2005, only 5 remained. Sid White ran a large dairy farm in west Andover on Lowell Street. Wild Rose Dairy milk and cream bottles were a staple in most Andover kitchens. In 1960, White moved his farm to Argilla Road and opened a dairy bar on nearby Andover Street.

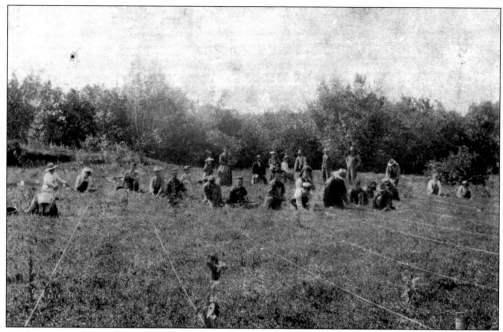

Andover has always been a town of farms, large and small. This image shows a cranberry bog owned by Ira Morse. As can been seen by the number of people working in just this small cranberry bog, pre-mechanized harvesting was a labor-intensive activity that provided seasonal employment for many.

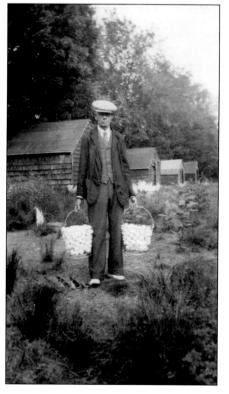

Sylvan Hollow was a poultry farm on Boutwell Road in the far west part of Andover. The farm raised chickens, turkeys, and geese. This image shows farm owner Charles Newton gathering up the day's production from the henhouse.

Run by the Cromie family for many years, Red Farm was situated on Abbott Road within walking distance of downtown. The Cromies raised chickens and cattle and won several farming awards at local agricultural fairs. Despite its prime residential location, it remained an active farm well into the early 1960s, when an increase in property taxes made the venture unprofitable.

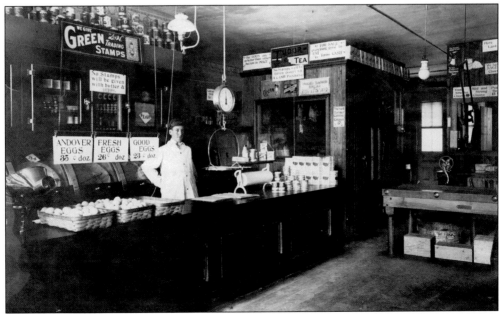

At the dawn of the 20th century, many proprietors operated more than one business, often under one roof. This image shows the interior of Lowe's Drug Store, complete with a butcher counter and canned goods. Note the different prices for eggs: being the freshest, local eggs cost the most. Look for the image of Lowe's 1930s-era ice-cream counter on page 78.

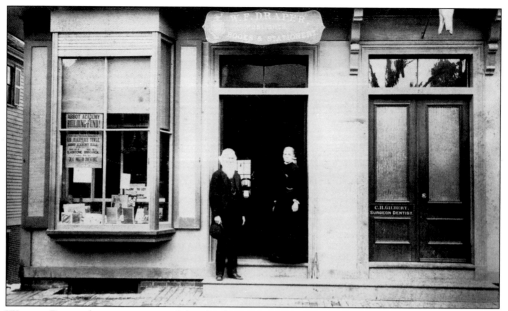

Warren Draper became owner of the Andover Press in 1854. In the 1860s, Draper moved the business from its location near Phillips Academy to the center of town at 37 Main Street. This image shows the storefront of the Draper Block where Draper continued to sell books and stationery to Phillips Academy and theological seminary students.

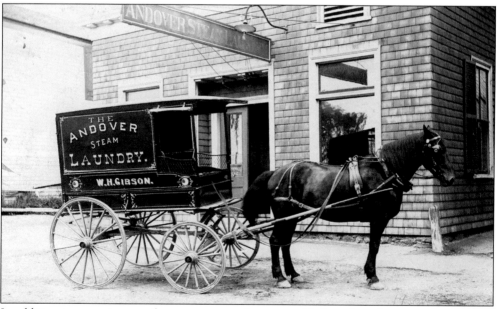

In addition to operating storefronts, many merchants provided goods and services door-to-door by wagon. This wagon was operated by William Gibson, owner of the Andover Steam Laundry on Post Office Avenue. The wagon collected dirty laundry and delivered freshly starched and pressed clothes daily. Several large laundry services operated in Andover until home washing machines became popular in the 1950s.

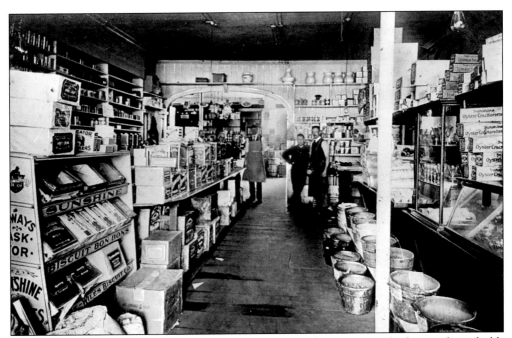

When Holt's General Store opened in 1834, it provided all the provisions the farming households of 19th-century Andover could not produce for themselves as well as a place for farmers to sell their produce to the rest of the community. By the time the store closed in 1924, not long after this photograph was taken, name brands and canned goods lined the shelves.

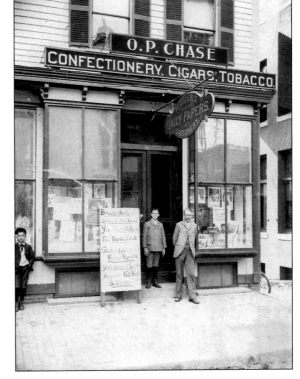

Omar Chase's store sold newspapers, stationery, and periodicals as well as many indulgences such as tobacco, cigars, and candy. The sandwich board relays the headline and sports scores of the day, including Pres. William McKinley's speech at Yale University and a "foul murder" in Hull. Chase was succeeded by Perry Wilson, who changed the name of the store to the Andover News.

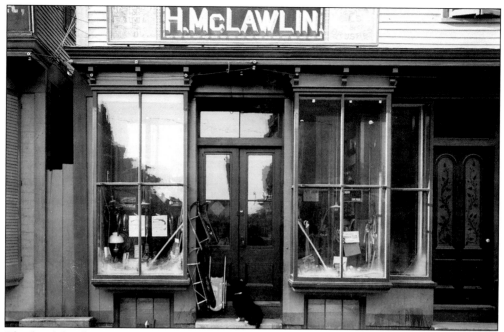

The local hardware store was a fixture of downtown Andover for almost a century. Henry McLawlin opened his hardware and general goods store in 1885. In 1906, McLawlin sold the shop to Walter Morse, who in turn sold to Rodney Hill in 1928. Hill's Hardware survived until the 1970s.

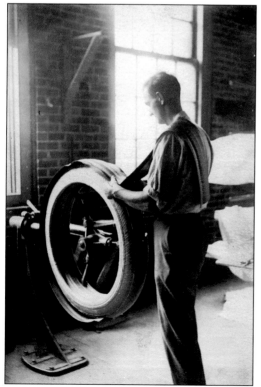

Tyer Rubber began in Ballardvale in 1856 on the site of the current fire station, producing rubber cement and a patented rubber shoe called a "compo." During World War II, Tyer was a major supplier of rubber floats, raincoats, and other products for the military and employed over 1,000 workers. In the 1950s and 1960s, Tyer produced rubber-soled footwear and pucks for the National Hockey League.

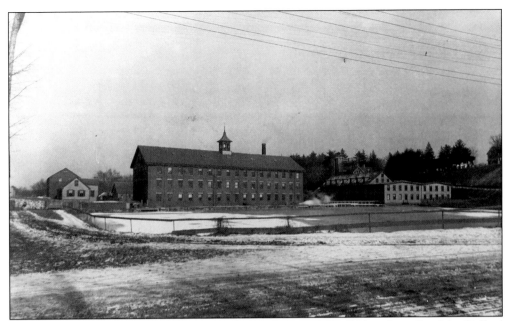

The mills in Ballardvale were begun in the late 18th century. In 1836, industrialist John Ballard constructed a major woolen mill. Ballard and his partners went bankrupt in 1857 and were bought out by Josiah Bradlee. Renamed Bradlee Mills, the company returned to profitability and was out of debt in less than 10 years. The 1836 building, seen here, is still occupied as a mixed-use office and business facility.

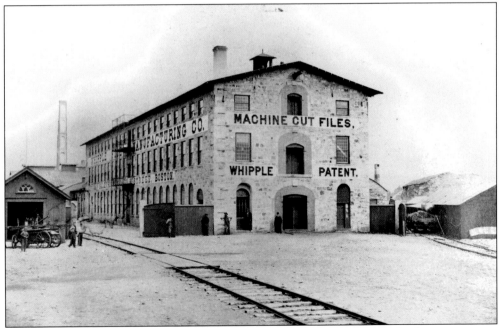

The Whipple File and Manufacturing Company, established in 1858, was the first company to produce steel files and rasps by mass-production machinery instead of by hand. It held several patents for both the process and the machines that made the files. It was eventually bought by the Richardson File Company of Rhode Island.

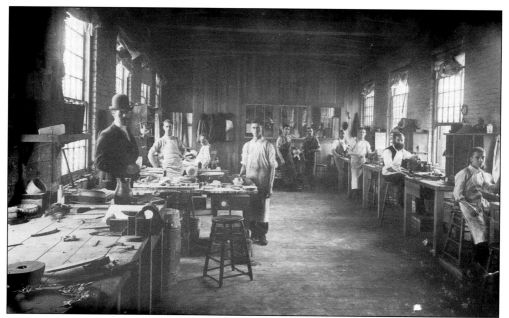

Craighead and Kintz was well known for producing fine metalwork in bronze and copper, especially lamps. A massive fire destroyed the company in 1898. Pictured here is a pattern and mold workshop around 1890. Note the very young worker at his bench to the far right.

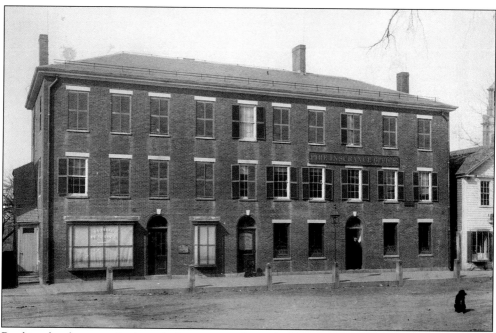

Banking has been an Andover industry since the early 19th century. Founded by a partnership between Andover businessmen in 1826, the Andover Bank became the Andover National Bank in the 1850s. The building seen here at 19–23 Main Street was the first location of the bank. It was demolished in 1886 to accommodate the new Andover National Bank building, which still exists as the home of the local Bank of America branch.

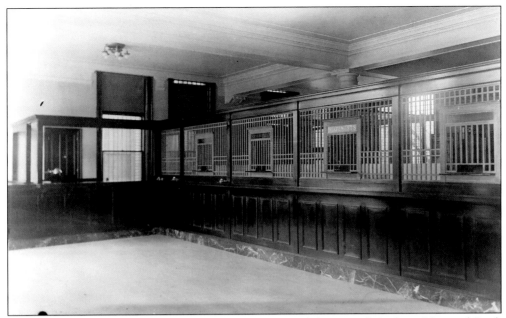

Brass cages and Victorian details decorate the interior of the second Andover National Bank building, built in 1886. The building was remodeled in the 1940s, removing many of the classic features. For a brief while, the Andover Savings Bank and the Andover National Bank shared space in this building until the Andover Savings Bank constructed a new office at 61 Main Street in 1924.

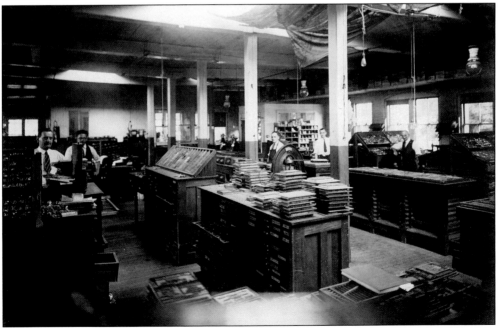

In 1887, Jack Cole became manager of the Andover Press for a new group of owners, adding the *Andover Townsman* weekly newspaper to the historic book and stationery business. In 1907, the company moved across the street to 60 Main Street, seen here. The Andover Press soon also became known for printing yearbooks and even *National Geographic* magazine.

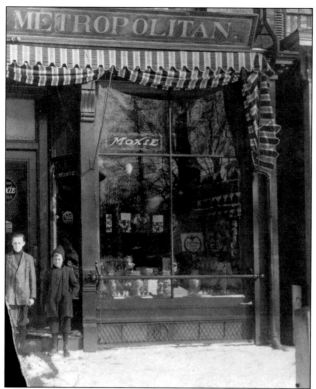

The Metropolitan Bakery was owned by Mary E. Dalton, grandmother to *Andover Townsman* columnist Bill Dalton. She bought the bakery at 42 Main Street in 1908. The store sold candy and sandwiches as well as baked goods. In the 1920s, Dalton expanded her business to include lunches and baked goods for the school district. This new enterprise proved more profitable than the storefront, and the Metropolitan Bakery closed.

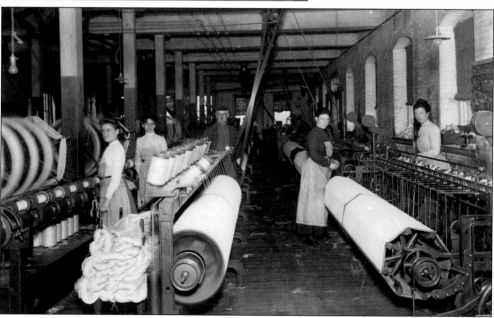

In 1836, Scottish immigrants John Dove and brothers Peter and John Smith began the first production of flax in America. They purchased the mill facility in Abbott Village in 1843, expanding it to include linen, twine, and sailcloth. John Dove many several trips to his hometown of Brechin, Scotland, to recruit inexpensive labor for the factory. The homes along Brechin Terrace were built to accommodate Smith and Dove workers.

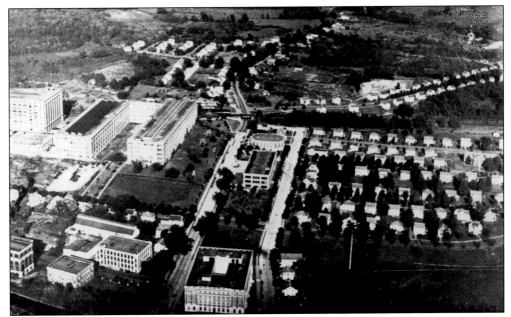

The Andover Woolen Company was at the heart of the planned community of Shawsheen Village. The factory/warehouse is visible to the left, the "white Shawsheen" garage is in the center (serving the neighborhood on the right), and the administration building is in the lower middle. Note the large expanses of lawn in front of the factory, now parking. This was the company's most productive facility until closing in 1957.

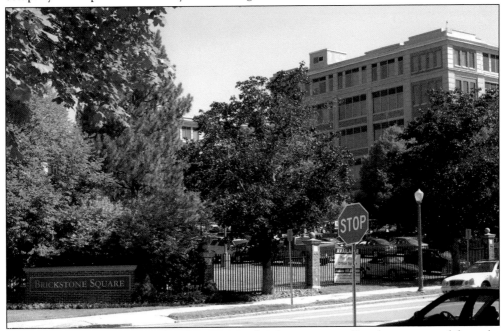

Following the American Woolen Company, technology company Raytheon operated from the large factory complex on Haverhill Street until moving to larger facilities in 1968. Today the buildings are a multiuse commercial complex known as Brickstone Square, which is home to various companies.

The Andover Consumer's Cooperative was begun in 1938 during the Great Depression. Members bought shares in the company, which worked in partnership with other markets for better prices on products. The market test kitchen experimented with new foods and recipes. The co-op survived the 1950s, despite a national trend concerned that cooperatives were communist and therefore un-American. The market boasted over 3,000 members at its peak in the late 1960s.

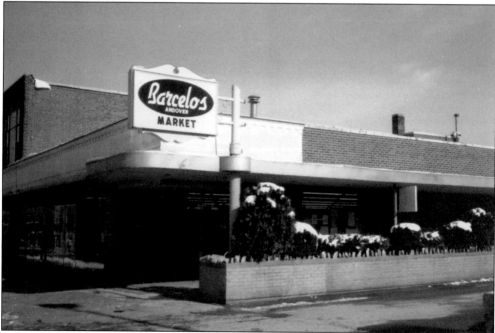

Brothers John, Jose, and Carlos Barcelos purchased the Andover Consumer's Cooperative in 1975 and ran the market for 15 years. In 1990, they closed the market and added an expanded second story to the building for office space.

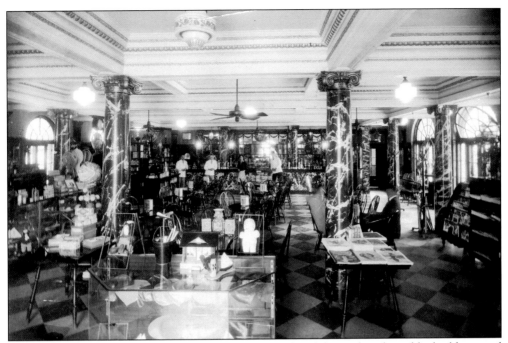

The interior of Balmoral Spa shows the opulence and detail devoted to the public buildings and shops in Shawsheen Village. Marble pillars and floors, gilded ceiling details, and brass fixtures welcomed visitors coming in just to buy the morning newspaper or ice cream.

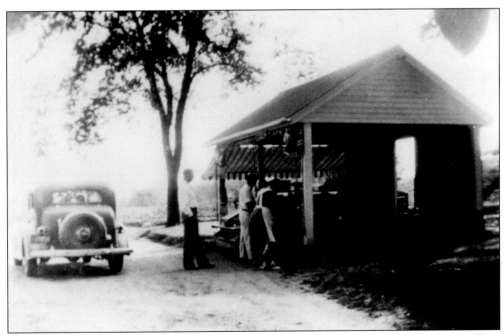

Roger Lewis ran a farm and a fresh produce stand on Lowell Street for many years. Lewis's efforts to draw attention to the plight of family farms in Andover helped pass legislation in the 1960s that assisted farmers who were being offered large sums of money by developers and facing increased property taxes.

Built in 1965, the Internal Revenue Service processing facility on Lowell Street is a major hub for processing federal tax returns from across the northeastern United States. The facility regularly employs almost 2,000 people, which increases to over 3,500 each tax season. Over 28 million federal tax returns were processed here in 2007, of which 20 million were filed electronically.

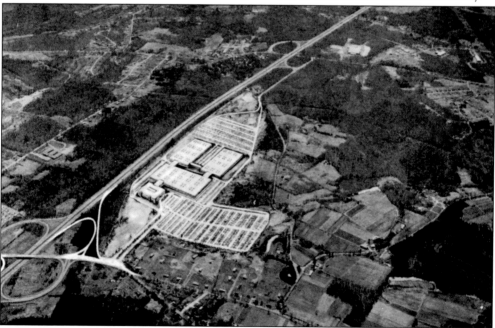

In 1968, Raytheon relocated from the old American Woolen Company mill building in Shawsheen Village to a much larger, purpose-built space in west Andover, closer to the interchange of Interstates 93 and 495. This complex was the site of major technological innovations in the defense industry, such as the Patriot missile guidance system.

Five

RECREATION AND CELEBRATION

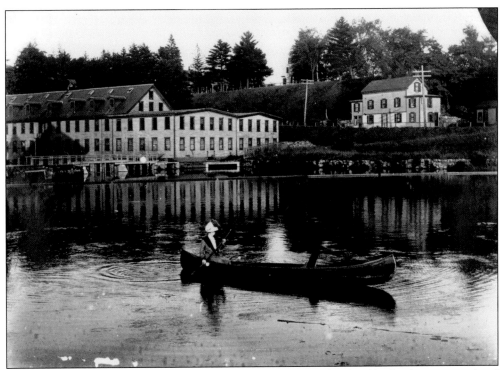

The millpond created by damming the Shawsheen River formed a placid body of water considered ideal for leisure activities, such as rowing or swimming. Here a solitary canoeist enjoys the waters. The Ballardvale mill complex is in the rear of the picture.

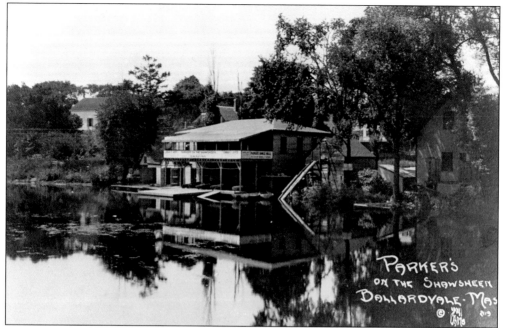

In the late 19th and early 20th century, Ballardvale was known as a recreational destination. Picnickers took the train from Boston or Lawrence to enjoy the fresh air and clean waters of rural Andover. Parker's on the Shawsheen was a canoe rental on the riverbank in Ballardvale. The facility also maintained a ballroom on the upper level. This image shows Parker's around 1900.

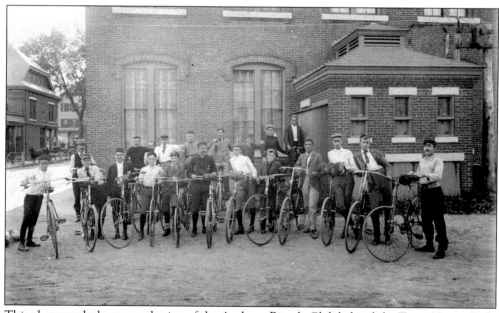

This photograph shows a gathering of the Andover Bicycle Club behind the Town House. Early bicycles were prone to tire punctures and had little in the way of padding or suspension for riding over cobblestones and unpaved streets, but as the image shows, the sport had broad support from all age groups.

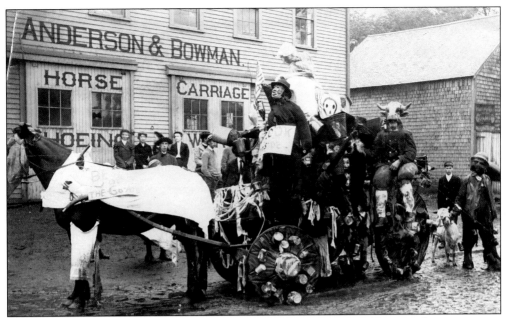

A "horribles parade" is a timed-honored New England tradition. Floats and wagons were decorated each Fourth of July and paraded through the town. Float decorations often conveyed political or social commentary, some of which would be considered inappropriate or offensive today. The Andover horribles parade fell out of favor after World War II but was revived in the 1980s, with children decorating their bicycles for the procession.

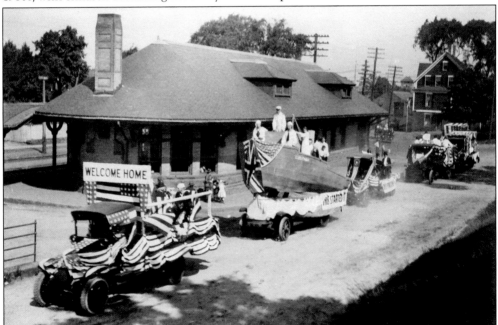

Following the end of World War I, the town of Andover hosted a grand parade. This image shows a set of floats, one demonstrating what started the war (the sinking of the *Lusitania*, according to the float builders) and the other showing what ended it (the signing of the Treaty of Versailles). The parade is passing by the 1905 railroad station, now offices and shops.

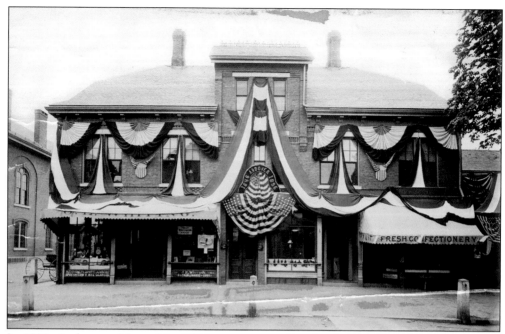

In 1896, Andover celebrated its 250th anniversary. Parades, lectures, historic presentations, concerts, and other events filled the year, with the highlights occurring on or near May 6, the day the town was incorporated. Many buildings, such as the Barnard Building on the corner of Main and Barnard Streets, seen here, were decorated in patriotic and historic bunting.

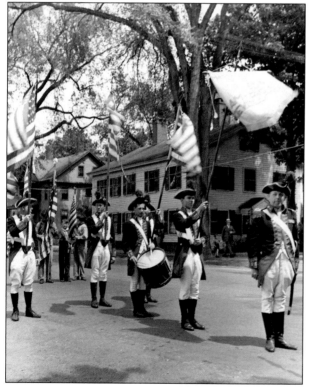

Andover's 300th anniversary in 1946 was made even more special as it coincided with the return of many soldiers at the end of World War II. This image shows the Andover Sons of the American Revolution as they form up for a parade.

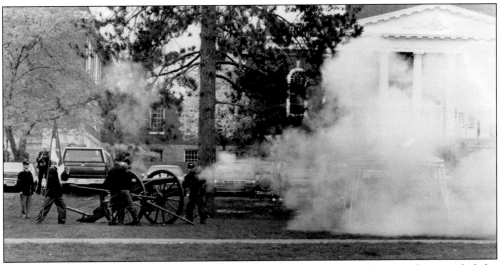

Not to be outdone, Andover's 350th anniversary featured parades and events that equaled the celebrations held a century earlier. In this image, Civil War reenactors fire a cannon in Central Park as part of the festivities.

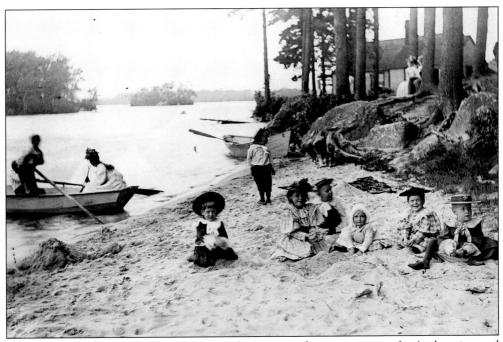

Haggett's Pond in west Andover has been a favorite spot for picnic outings for Andoverites and out-of-town visitors alike. A group of vacationers is seen here on the shore of Haggett's Pond in the 1890s, enjoying both the beach and rented rowboats.

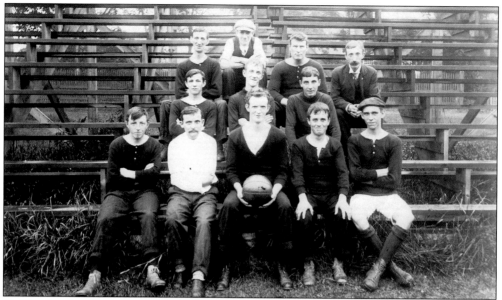

Phillips Academy has a long-standing tradition of athletic excellence as well as academic. Matches were arranged between not only other schools but also community teams. These two images are believed to have been taken in November 1919 at a soccer match between the Chinese student soccer team of Greater Boston (below) and a team from Phillips Academy (above). While the Boston team was considered a strong competitor and the odds-on favorite, the Phillips team defeated them 2-1. An *Andover Townsman* article about the match notes that the game ended well after sunset. The article also mentions that one of the players was born in the Philippines and was the son of the personal secretary to Emilio Aquinaldo, a prominent figure in Philippine politics at the time. Aquinaldo's son would also attend Phillips.

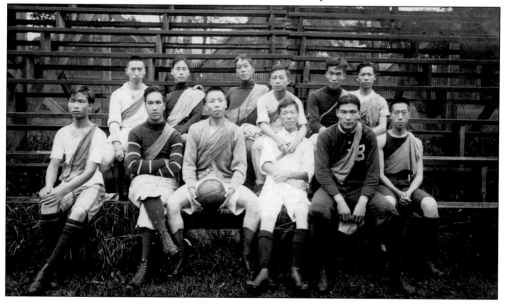

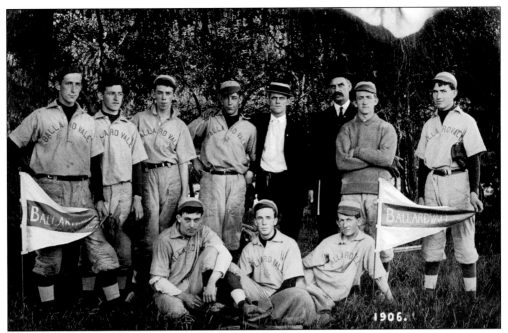

Local communities often organized amateur municipal sports teams to compete against neighboring towns. This image shows the Ballardvale baseball team around 1906.

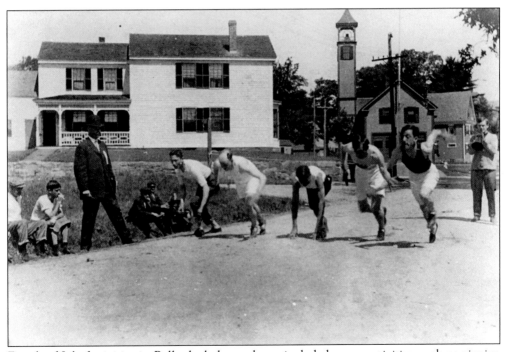

Fourth of July festivities in Ballardvale have always included many activities, such as picnics, speeches, parades, and a footrace. Note the Ballardvale firehouse tower in the rear of this image from the 1909 festivities.

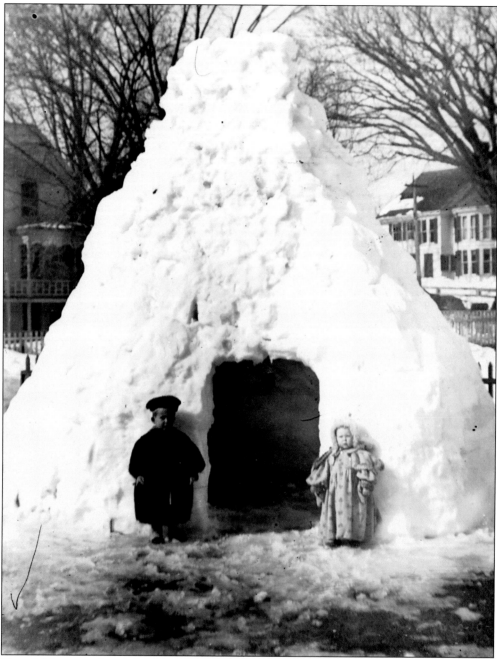

Two children stand in front of a substantial snow fort in this image taken after a blizzard in February 1898. Snow removal was a labor-intensive process until the early 20th century and the invention of the snowplow. Clearing streets and sidewalks by shovel with horse-drawn carts meant clean up after a major storm could take days.

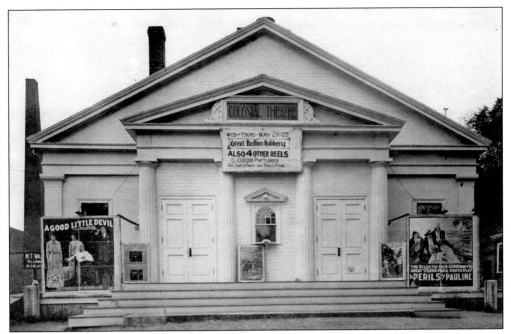

Originally built as a train depot and later used as a tinsmith's shop, the Colonial Theatre at 9 Essex Street was Andover's first movie house. The release dates of the two films posted outside the theater, *The Good Little Devil* and *The Perils of Pauline*, date this photograph to 1914. Note that the latter was a high-budget film, costing over $25,000.

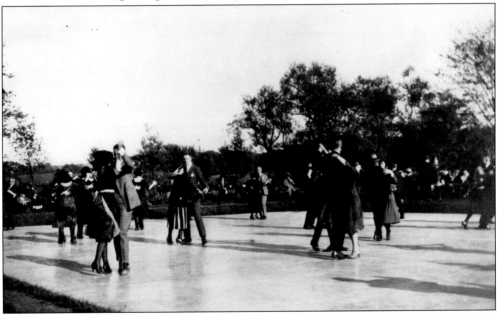

Shawsheen Village had two spots for dancing, both on Andover Woolen Company property. The Crystal Ballroom on Haverhill Street was the indoor ballroom used mostly in the winter months, and the Balmoral Spa hosted an outdoor ballroom along the Shawsheen River in warmer weather. The ballroom was a popular weekend venue, but crowds diminished during the Great Depression, and the dances ended soon after World War II.

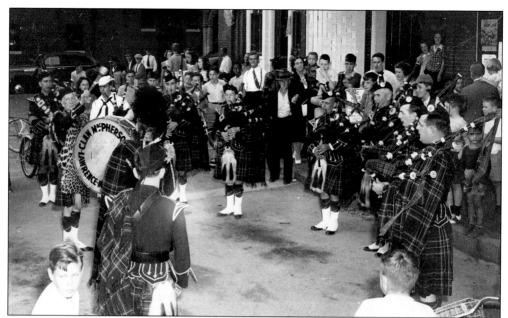

Andover citizens responded to World War II with courage and self-sacrifice. Over 1,700 Andoverites served in the armed forces, while scrap drives and rationing became part of everyday life on the home front. Seen here, Clan MacPherson Scottish Pipes and Drum Corps rallies the citizens during a 1943 bond drive in front of the Town House. Note the piper in the navy uniform to the left.

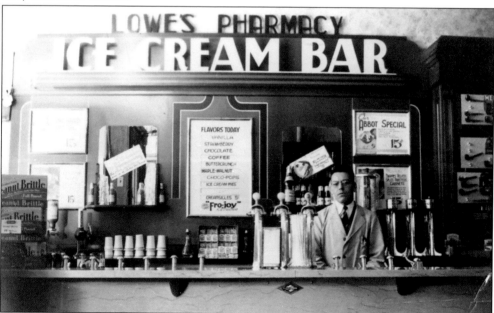

The ice and soda counter at Lowe's pharmacy was a regular after-school destination for Andover students, as were the counters at Simeone's, Hartigan's, Dalton's, and all the other Andover soda fountain counters in their time. The Andover Spa counter was the gathering space for Andover night owls. While the soda fountains disappeared in the 1960s, the tradition of students gathering in various downtown shops persists to this day.

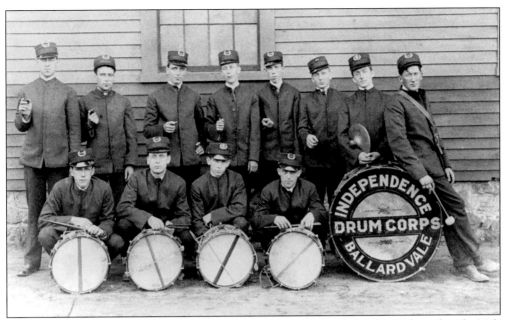

This image shows the Ballardvale Community Marching Band. In the 19th and early 20th centuries, many employees still lived within walking distance of their jobs and frequently found themselves living alongside coworkers, spending significant amounts of leisure time together. Organizations like bands, teams, and clubs were often the result of community ties and shared interests.

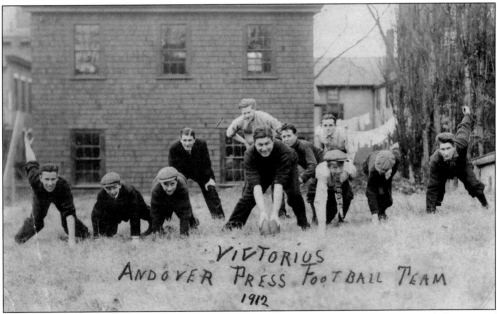

This image shows the Andover Press football team practicing in 1912. Note that while some of the players are adults, several members of the team are very obviously boys. While it is unknown who the young gentlemen competed against, the word "victorius" has been written on the card as an afterthought. It is hoped whoever misspelled the word *victorious* was not in charge of the typesetting!

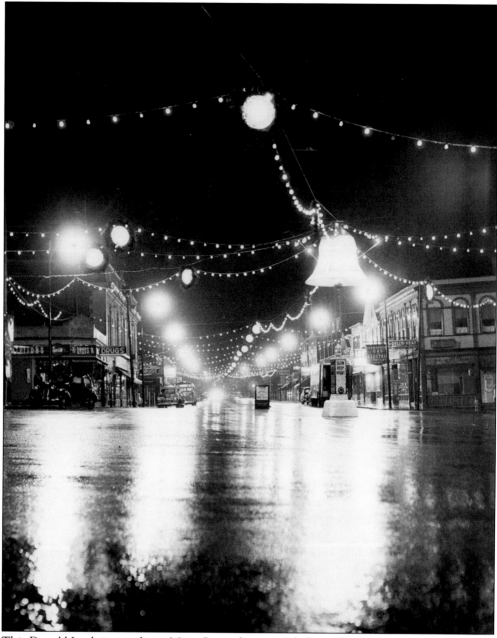

This Donald Look image shows Main Street facing south from Elm Square in 1950. Taken on a rainy evening near the holidays, the elaborate lights strung for several blocks of Main Street brightly illuminate this late-night scene.

Six

HOUSES AND HOMES

Built in 1832, the house at 106 Main Street belonged to Amos Abbott, prominent businessman, deacon, and one of the founding board members of the Andover National Bank. The house is shown here decorated for Andover's 250th anniversary celebration in 1896.

In 1831, while a student at the Andover Theological Seminary, Samuel Francis Smith wrote the poem "America," more commonly known as the song "My Country, 'Tis of Thee." Smith was inspired to write the poem after being asked to translate patriotic songs and hymns from German. While attending the seminary, Smith resided at this house at 147 Main Street. The building is now a Phillips Academy dormitory.

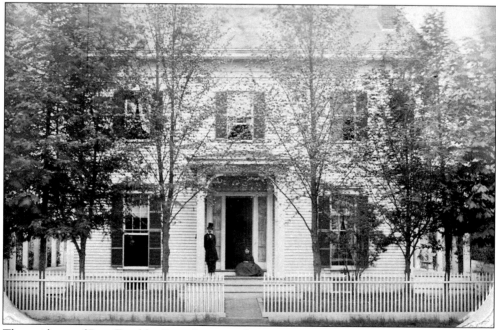

The residence of Pres. Franklin Pierce's sister-in-law was at 48 Central Street. Pierce, his wife, and their children visited for extended periods, giving it the nickname "the summer White House." Pierce's young son Benjamin was killed in a train wreck in Andover in January 1853. Benjamin's wake was held at 48 Central Street. In 1863, Pierce's wife also passed away at this address.

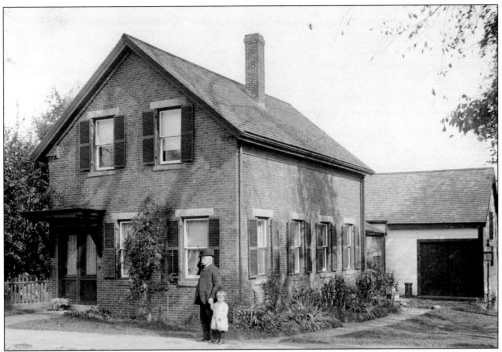

Unusual for its brick construction amid a collection of wooden-frame buildings, this small cottage was built at 8 Marland Street in Ballardvale. It was the rectory for the Ballardvale Methodist Church until it merged with the United Congregationalist Church in 1955. The church the rectory served was demolished in 1967, but the rectory is now a private residence.

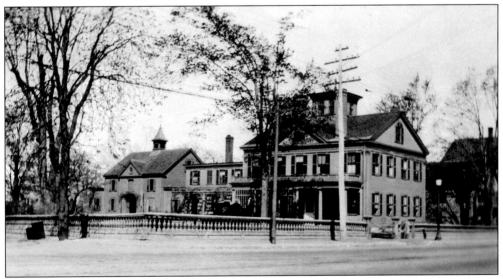

Nathaniel Swift was a president and later a board member of the Andover Savings Bank. His home was relocated from the corner of Main and Chestnut Streets to farther down Chestnut Street in 1924 for the construction of the Andover Savings Bank. However, the reprieve was only temporary; the building was demolished in 1967 to make space for an expansion of the bank and additional parking.

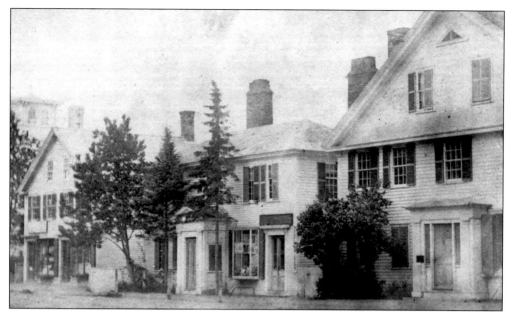

This photograph shows a pair of private houses on Main Street around 1860. Originally these buildings were two-story private homes. As Main Street became more commercial and less residential, front parlors were often remodeled into storefronts. Note the house in the center of the photograph; the proprietors of the store have built a second entrance to the building and added a large window to display their wares.

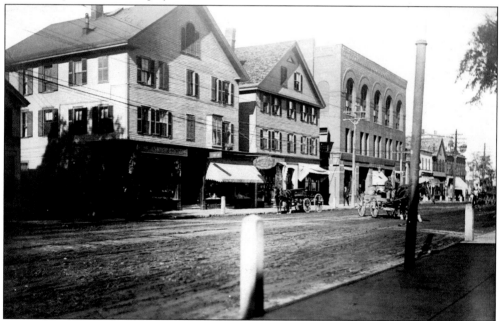

This image shows the same houses in 1910 with a new floor added at the bottom. Note the unchanged overhang of the upper floor and small triangle window at the peak of the building to the right. The bay window in the first photograph is now on the second floor. To accomplish this addition, buildings were slowly elevated on successively higher timber platforms, and a new first floor was constructed below.

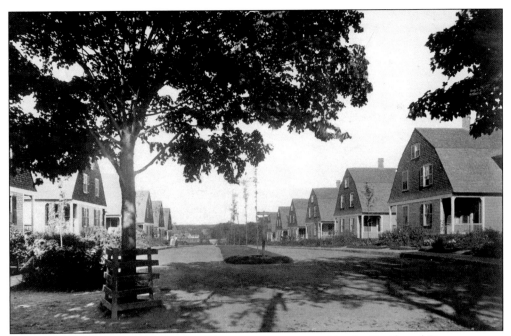

Developed and built in 1906, Brechin Terrace was constructed by the Smith and Dove company as housing for workers. The street was named after the Smith brothers' and Dove's hometown of Brechin, Scotland. Many of Smith and Dove's first employees were recruited from the same town.

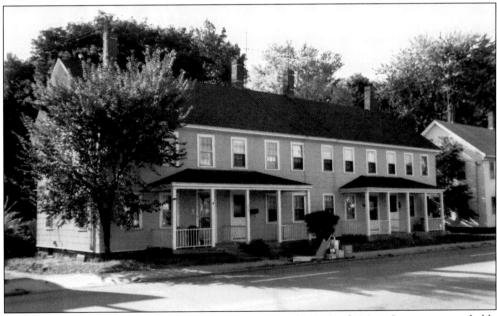

These buildings, part of a row of houses between 194 and 222 North Main Street, were probably built in the first half of the 19th century. Inexpensive mill housing first accommodated employees of the nearby Marland Mill and workers from the American Woolen Company in Shawsheen later in the second and third decades of the 20th century. Similar buildings can be found near the Ballardvale Mills and other mill or factory sites across town.

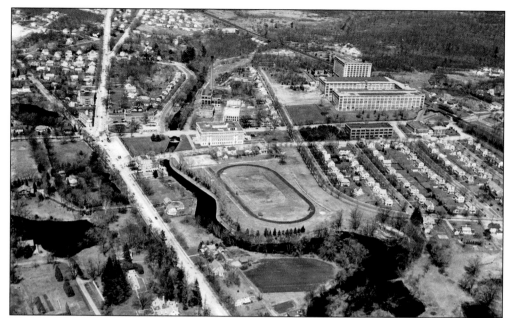

This aerial photograph shows Shawsheen Village around 1940. On the right, the houses of "white Shawsheen" are laid out in uniform rows and equal lots, while several large house lots remain open on North Main Street south of Shawsheen Square. William Wood's mansion, Arden, is just visible at the bottom left of the image. At the top of the image, open space will eventually be occupied by Interstate 495.

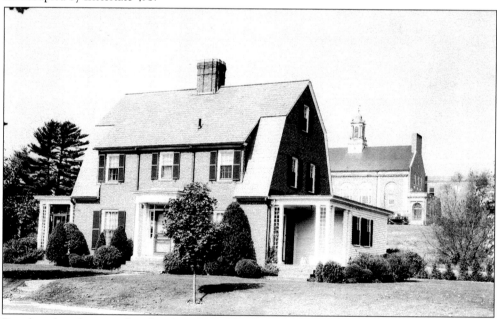

Developed as housing for the American Woolen Company's executives as part of Wood's planned community, Shawsheen Village, the homes of "brick Shawsheen" were placed on the open market by Wood's successor at the company in the mid-1920s, only a few years after they were built. To this day, many still lack a common feature: a garage. Note Shawsheen School to the rear of the image.

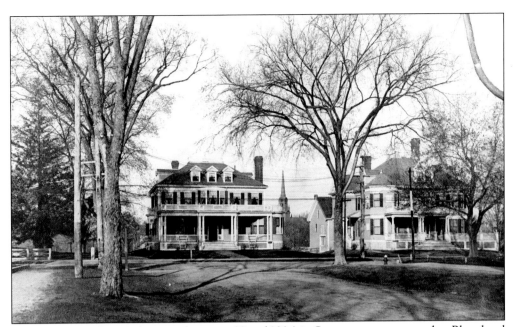

Both built around 1900, these two houses at 89 and 93 Main Street were constructed on Blanchard Farm orchard land. Dentist Albert Hulme maintained an office at his home on the left for over 50 years. Dr. Cyrus Scott likewise saw patients in his home office. Scott's home briefly served as the Maywood Inn in the 1930s and later as the office of dentist Nathaniel Stowers.

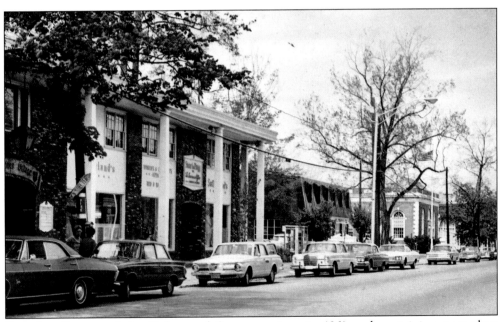

Built literally around the Hulme and Scott mansions in 1961 and containing more than 50 boutiques, businesses, and offices, Olde Andover Village is the largest single retail complex in downtown Andover. A large addition was added to the rear of the building in the 1980s. The rooflines of the original mansions can still be seen from across the street. The Andover Bookstore occupies the former barn from the Scott mansion.

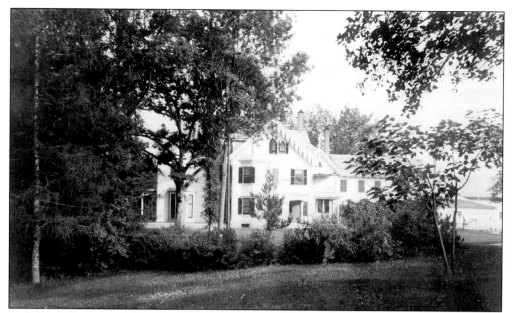

Built by mill magnate John Dove in 1847, the North Main Street estate purchased by William Wood in the late 1880s as a summer home was renamed Arden. Wood became so fond of Arden and Andover that he not only moved his family from Winchester permanently but also elected to relocate the offices of the American Woolen Company to Andover rather than commute to Boston. The mansion was surrounded by over 60 acres of woods and former farmland.

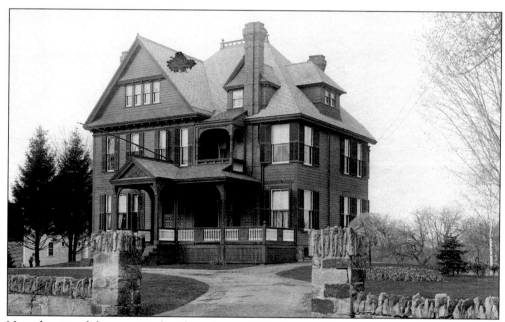

Now the site of the municipal parking lot on Main Street, this mansion was built in the late 19th century by James Smith, president of the Smith and Dove company. It was purchased by the town and used as veterans' apartments and the local Red Cross chapter offices. It was briefly considered as a possible new location for the town offices. The building was demolished in 1957.

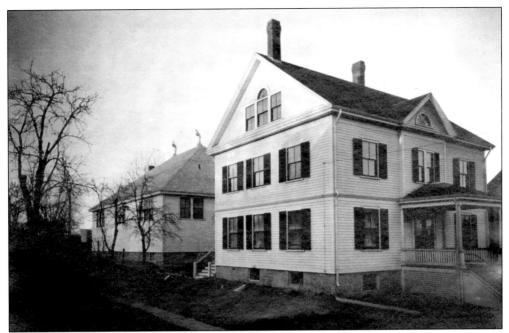

Founded in 1896, the Andover Guild was a charitable organization that focused on children, providing activities and teaching skills such as saving money. The guild also founded the first kindergarten in Andover. The large building to the rear of this house at 10 Brook Street is not a garage or barn but a gymnasium, built in 1897. The guild's activities were taken over by the YMCA in 1968.

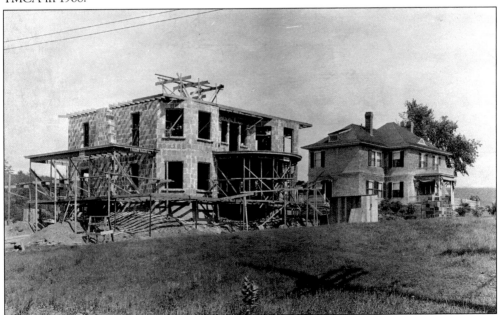

The two houses in this image were constructed around 1900. On the left, 64 Bartlet Street is being built for the Jealous family, while 66 Bartlet Street, home of the Melledge family, has already been completed. Although it appears both homes are being built in an open field, the road is obscured by the curve of the hill.

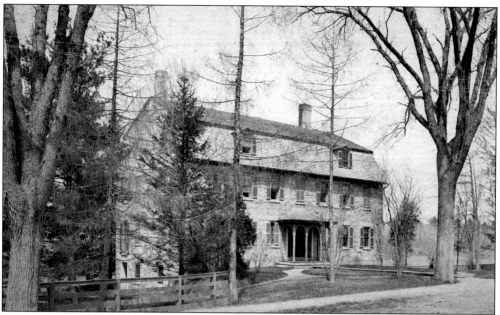

Originally a carpenter's shop, the home of Harriet Beecher Stowe and husband, Calvin Stowe, was located on the edge of the Andover Theological Seminary grounds on Chapel Avenue. The Stowes moved to Andover when Calvin accepted a teaching position at the seminary in 1852. Now part of Phillips Academy, the building was used as an inn and was moved to its present location on Bartlet Street in the 1920s.

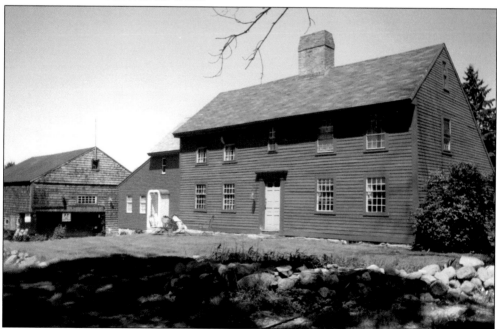

This home at 7 Hearthstone Place is over 300 years old but has only been on Hearthstone Place for a handful of those years. Built by Thomas Blanchard in 1699, it was located at the center of a 50-acre farm that included a cobbler's shop on what eventually became Osgood Street. The house was moved to its present location and extensively restored in 1988.

Seven

MAIN STREET MEMORIES

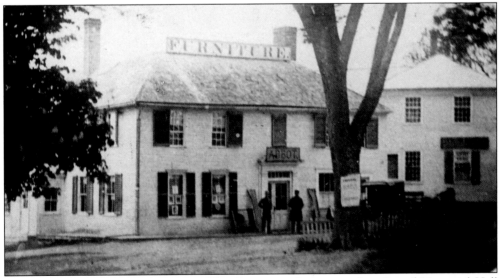

Abbot Furniture shop was located in Elm Square on the current location of Memorial Hall Library. It was most likely built as the home of Joseph Sibson in the late 18th century. Brothers Joseph and Herman Abbot constructed and sold wooden furniture at the site from 1840 until a fire destroyed the building in 1870.

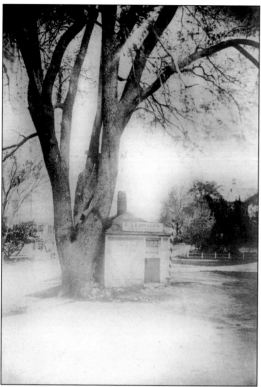

E. A. Edwards's hairdresser's shop operated in the center of Elm Square in the mid-19th century. Edwards also held the local grain scale franchise, the large scales for which were located behind the building. It is unknown when the shop was removed, but the giant elm under which it sits was deemed a traffic hazard and cut down in 1919.

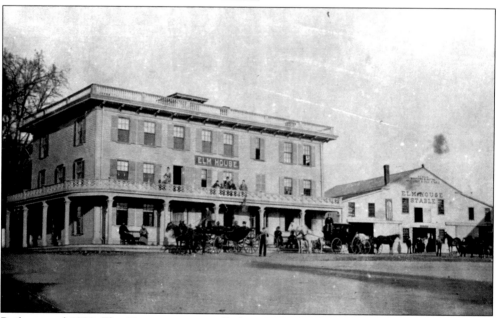

Built around 1800, Elm House was originally known as the Ames Tavern, one of several inns in Andover for visitors and travelers along the Essex Turnpike (now Route 28). A large carriage house and stable existed to the rear. In 1895, businessman John Flint purchased Elm House and dismantled it. The Musgrove Building was constructed on approximately the same site that year.

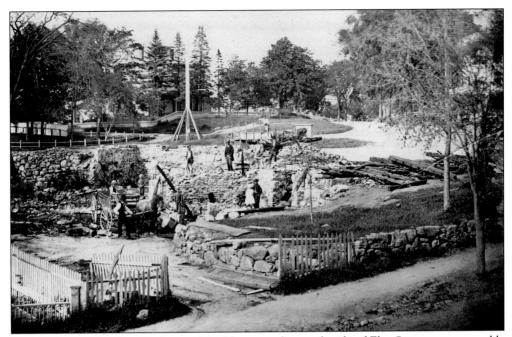

In May 1870, a fire destroyed several buildings on the north side of Elm Square, most notably Abbot Furniture. This image, looking east up Elm Street, shows all that is left of the building and the stone foundation. The Punchard/Barnard Mansion can be seen in the background. In 1871, the site was acquired by the town to build Memorial Hall Library.

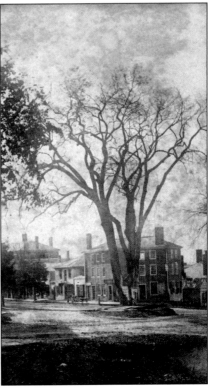

This photograph shows the eponymous elm tree in the center of the Elm Square, called the centennial elm. The Federal-era building seen behind it is the Carter Block, destroyed by fire in 1882. From 1953 to 1992, that corner of Main and Central Streets was also the location of Macartney's, a popular men's clothing shop founded in Lawrence in 1880. It is now the site of Kap's, another longtime regional clothing store.

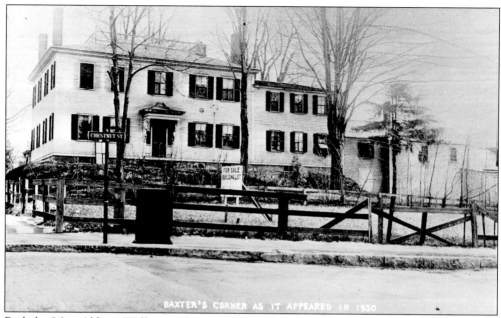

Built by Maj. Abbott Walker in the early 1800s, this mansion at 71 Main Street was later the home of Rev. Justin Edwards, a founder of the American Tract Society and president of the Andover Theological Seminary. It was demolished in 1930 to build a new post office. The empty field in the foreground was the site of annual Christmas tree and fireworks sales. It is now Andover Gulf.

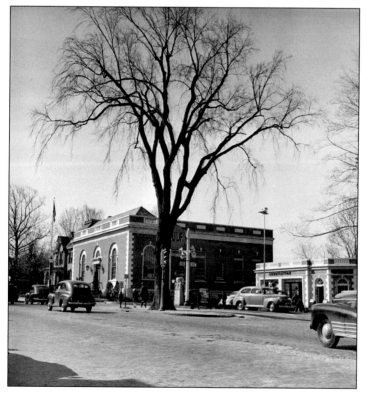

Charles Baxter established Baxter's Service Station in the long-empty lot on the corner of Main and Chestnut Streets in 1936. Despite his efforts to unofficially christen the intersection "Baxter's Corner," the name never caught on. The post office, built in 1931 on the site of the Walker/Edwards house, appears in the background.

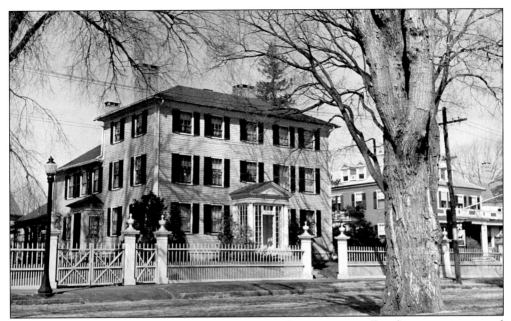

Built in 1819, the Amos Blanchard house at 97 Main Street was actually a farm covering several acres. Berry patches and grapes grew to the south, while apple and cherry orchards grew to the north almost all the way to Chestnut Street. The house has been the headquarters of the Andover Historical Society since 1929. Note the Hulme Mansion on the right of the photograph, now part of Olde Andover Village.

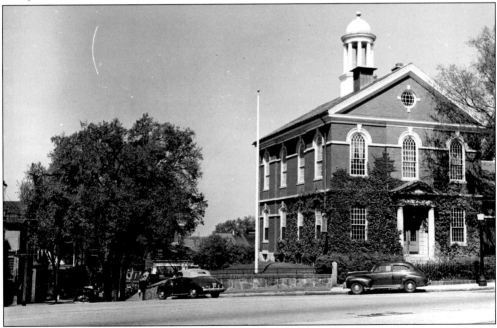

In 1927, Memorial Hall Library was extensively remodeled, with a new reading room added to the north side of the building. The roofline was changed, adding a bell tower, and the Victorian details were replaced with a brick classical/Georgian motif. The library was expanded several more times to accommodate a growing town in the coming years.

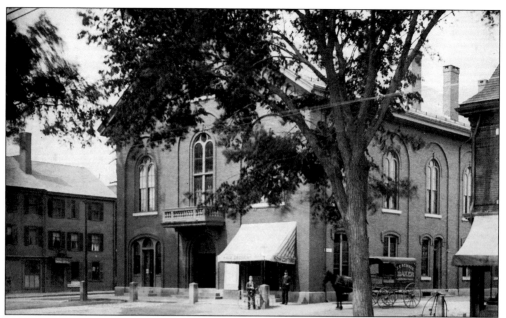

When Andover and North Andover split into separate towns in 1855, a new town meeting hall was needed. After meeting in local churches and even private homes for three years, a new hall (known as both the Town House and town hall) was built on Main Street in 1858. A post office substation and a barber leased storefront space on the first floor to help defray construction and maintenance costs.

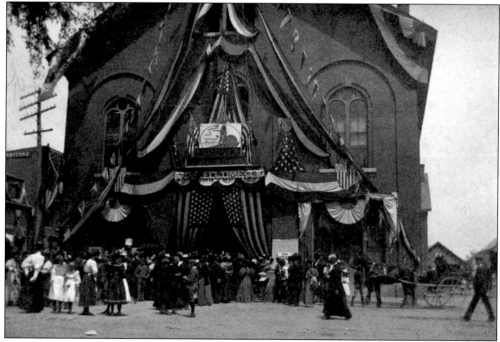

The Town House has been the center of public gatherings, displays, and celebrations for many years. In this picture, the building is decorated in bunting and banners to celebrate Andover's 250th anniversary. Note the large rendition of the town seal hanging from the balcony.

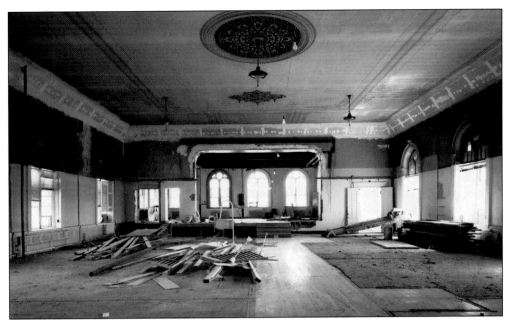

During World War II, the Town House auditorium was subdivided into office space. False walls and a drop ceiling were installed, obscuring the decorated ceiling, windows, and stage. This image shows the auditorium during remodeling in 1989. The two paint colors indicate where the false walls ended. The restored hall was made to appear as it looked after a 1902 remodeling but added modern conveniences such as handicapped access and air-conditioning.

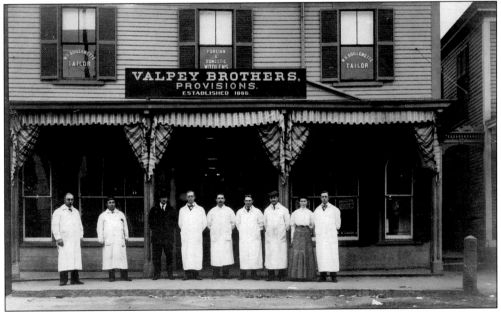

In the 1820s, the Valpey family owned a large parcel of land extending into Elm Square. Around 1830, Samuel Valpey established a butcher and tanning business on the site. His son Samuel George and grandsons George and Ezra continued the business, expanding it to include dry goods and provisions. When Valpeys closed in the 1890s, it was believed to be the longest continuous family-run storefront in Andover.

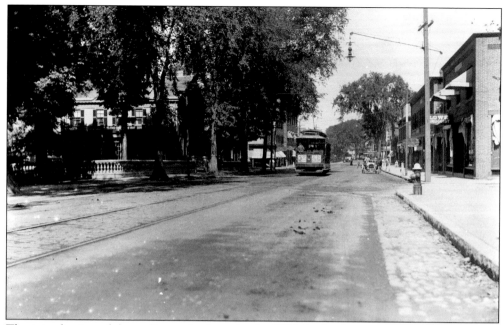

The introduction of the trolley to Andover in the 1880s had as big an impact on the town as the railroads did 50 years earlier. Andover was now quickly and affordably accessible to everyone from as far off as Boston or New Hampshire. Some citizens protested the trolley, believing it would reduce Andover to a weekend picnic ground for "rough crowds" and raucous visitors would disturb the general peace.

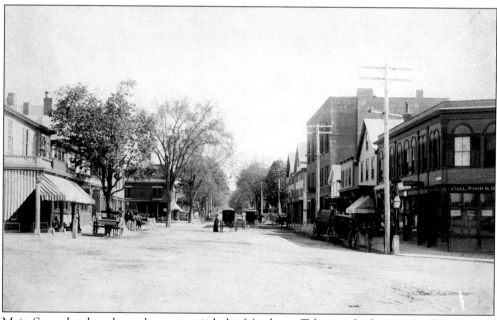

Main Street has long been the economic hub of Andover. Taken in the late 1800s, this image of Main Street, looking south, shows a tree-lined, unpaved road filled with buggy traffic. Granite hitching posts line the curb in front of the shops. Note the collection of timber-frame buildings on the left, all of which were removed to build the Barnard Block in 1910.

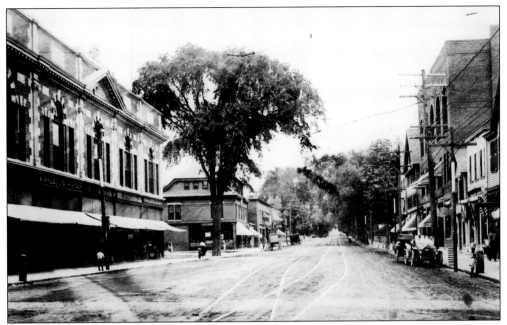

Here is the same view as the previous picture from around 1910. The Barnard Block now occupies the entire left side of the street. A large elm tree remains in front of the Town House, but several others up and down the block are gone. Note the trolley tracks in the center of the street but no overhead electrical lines. When first introduced in 1889, trolleys were horse-drawn "rail roads."

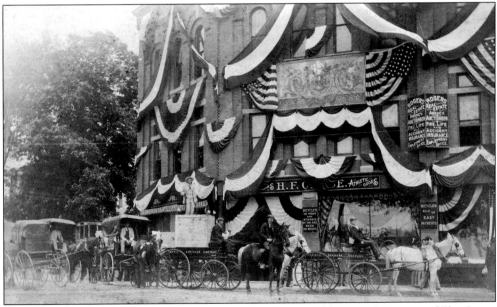

American Express maintained an office in the Musgrove Building on the corner of Elm Street for many years. Originally American Express was a money-order company as well as the nation's premier mail-order and package delivery service. This image, taken during the 1896 celebration of Andover's 250th anniversary, shows a fleet of horses and wagons ready to carry letters and packages across the country.

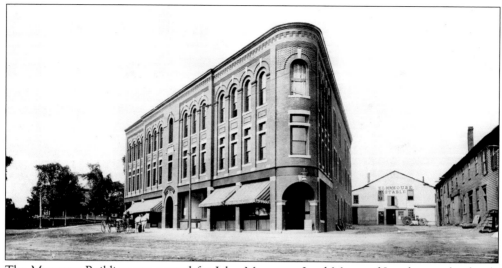

The Musgrove Building was named for John Musgrove, Lord Mayor of London, and a family friend of owner John Flint. Its flatiron shape and architectural details (like electricity and elevators) were cutting-edge when it was constructed in 1895, seven years before the Flatiron Building in New York City; architectural students came to Andover to study the building. The Elm House stables still stand in the background. The stable house became retail space and survived until the late 1960s.

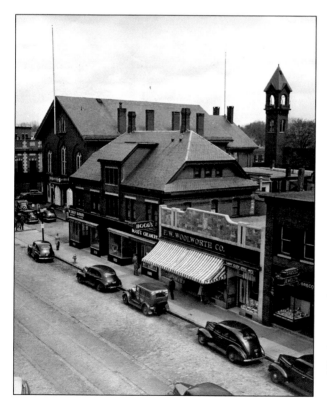

One of the oldest families in Andover, the Barnards operated a very successful shoe manufacturing company since the mid-1800s. By 1900, patriarch Jacob Barnard's various businesses employed over 200 people. In 1883, he built the Barnard Building, a three-story office and retail building at 38 Main Street, shown here, as well as another building at 19 Barnard Street in 1887 for his shoe factory.

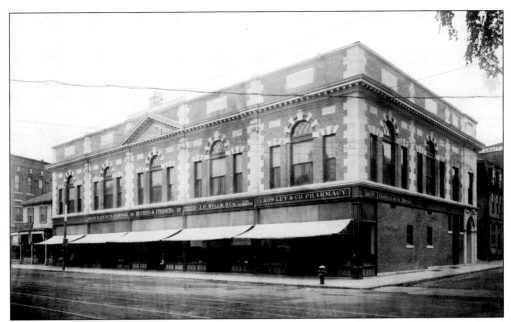

Barnard's son Henry built the new Barnard Building or Barnard Block in 1910. It replaced a group of aging structures, including Wakefield's Provisioners and the Andover Hotel. The building has been the home of many popular Andover businesses, including Ford's Coffee Shop, Cole's Hardware, and, in succession, Crowley's, Lowe's, Dalton's, and Hughes' drugstores. The Barnard Block was added to the National Register of Historic Places in 1982.

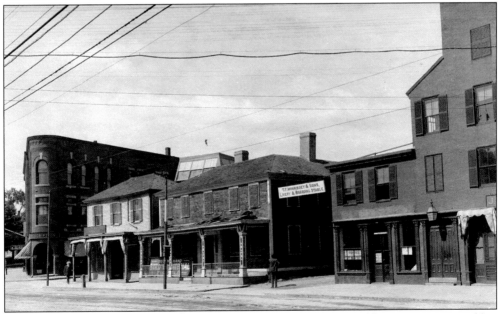

This image dates from between 1895 and 1910 after the Musgrove Building was constructed but before the Barnard Block. From left to right are the Musgrove Building (constructed in 1895), Valpey's Market, the Andover Hotel (both built in the early 1800s), the former site of Saunder's Plumbing Supply (unknown date), and Wakefield Provisioners (built in 1800). Note the sign indicating Morrisey's Livery Stable to the rear of the hotel.

Built by Benjamin Punchard in 1846, the Punchard/Barnard Mansion sits atop the hill at the north end of Elm Square. It was later occupied by Jacob Barnard, who owned several properties in the neighborhood. It is currently occupied by Enterprise Bank, who extensively restored the Italianate-style mansion in 2006.

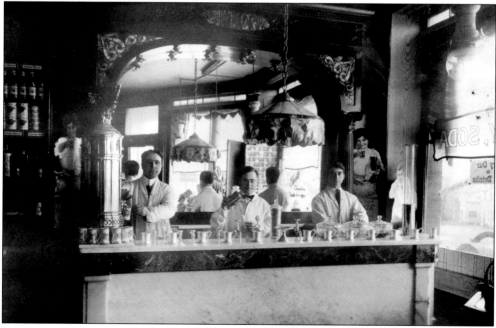

Simeone's pharmacy operated out of the Musgrove Building before Paul Simeone built his own storefront on the site of the former Valpey's Market in 1933. As time passed, Simeone's changed from a drugstore and soda fountain to a medical supply company and finally closed in 1994. The building, now an art gallery, still bears the name Simeone in concrete above the door.

This view from the second floor of the Musgrove Building shows Main Street looking south. Taken around 1895, the image of the veranda porch, horse-drawn wagon, and unpaved street makes this look like a scene out of the Old West rather than an East Coast town at the dawn of the 20th century.

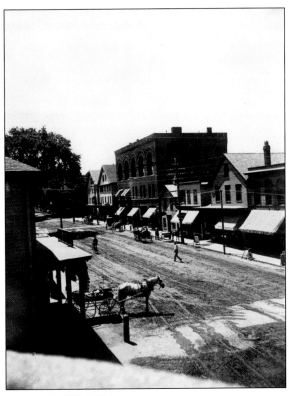

This 1993 photograph was taken from the same window as the previous image. While the two-story wooden-frame building in the foreground that housed Valpey's Provisioners has been replaced by the single-story Simeone Building, and the Barnard Block now occupies the space beyond all the way to Park Street, the buildings on the west side of the street are fundamentally unchanged after almost a century.

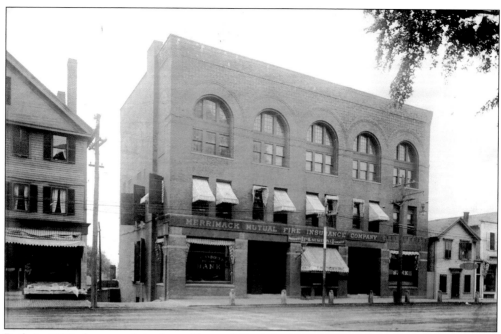

Built in 1889, the second Andover National Bank building still stands at 19–23 Main Street. The main floor held the Andover National Bank, the Andover Savings Bank, and Stacey's Drug Store. The second floor was occupied by the Merrimac Mutual Fire Insurance Company, while the upper floor was leased to the Andover Masonic Lodge.

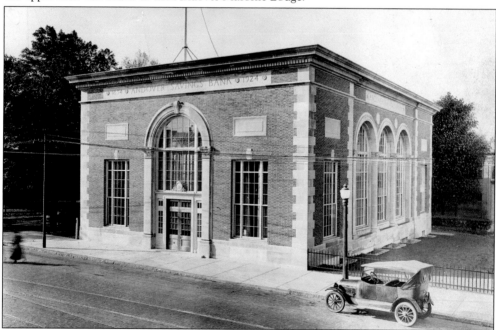

Founded in 1834, the Andover Savings Bank leased space in the Andover National Bank building for almost 75 years. In 1924, the trustees voted to construct their own building at 71 Main Street. Former bank president Nathanial Swift's 19th-century home was relocated to Chestnut Street so the new bank could be built.

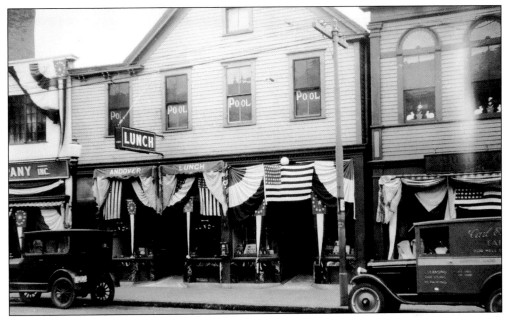

This image shows the Andover Lunch at 11 Main Street around 1926. The Andover Lunch opened in the 1920s and expanded into the storefront next door at 9 Main Street in the 1930s. In 1949, it became Lee's Lunch Counter. It is now the location of Strawberry Tree. The pool hall on the upper floor was operated by A. H. Eaton and only lasted for a few years in the mid-1920s. The space is now storage for the store below.

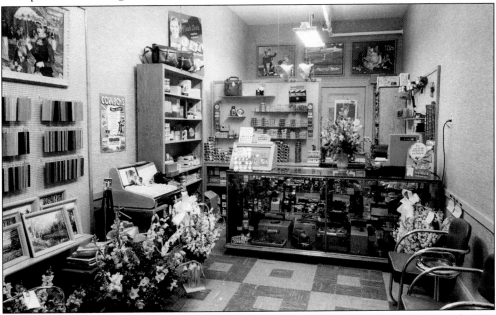

Donald Look continued the tradition of Andover photography through the 1940s and 1950s begun by Charles Newman a generation earlier. Opening his photography business while still in high school, Look was a frequent contributor to local papers. His Musgrove Building camera shop and photography studio, seen here, were acquired by employee Carlton Schulze in 1954. The business relocated to Barnard Street in 1978 under the ownership of Richard Chapell.

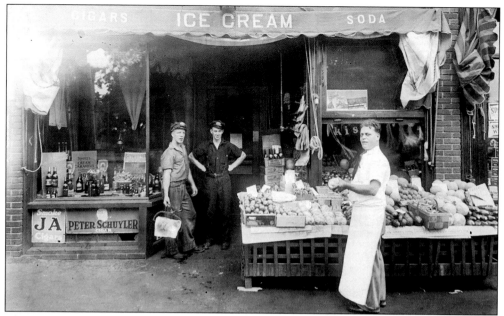

The Andover Spa at 9 Elm Street was founded by brothers George and Peter Dantos (seen here on the right) in 1921. They sold fruit, ice cream, newspapers, and magazines. George's son Phidias ran the business until 1969. The spa's soda counter was a late-night hangout and the scene of weekly chaos on Sunday mornings when the *New York Times* was delivered to an anxiously waiting crowd.

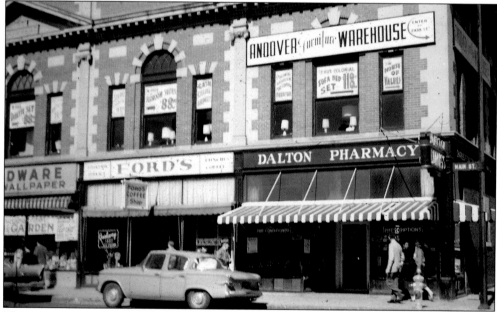

This image captures two iconic Main Street businesses: Ford's Coffee Shop and Dalton Pharmacy. Tom and Stella Koravos purchased Ford's in 1954, turning the former bakery into the center of activity on Main Street for 40 years. Charles Dalton purchased Lowe's pharmacy in 1943 and became the third drugstore owner on the corner of Park and Main Streets. He in turn sold to Alan Hughes in 1967.

Eight

PLACES OF WORSHIP

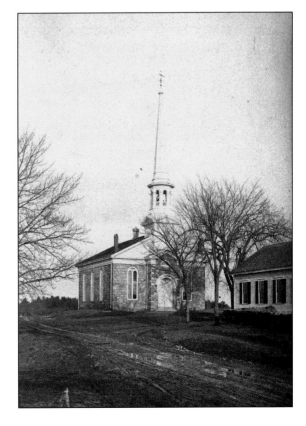

Created in 1826, West Parish Church was the third parish organized in Andover. Like South Parish Church, it was created to accommodate a growth in population that was too distant to easily reach Sunday services at the north or south parishes. The West Parish Church is the oldest continuously used church in Andover.

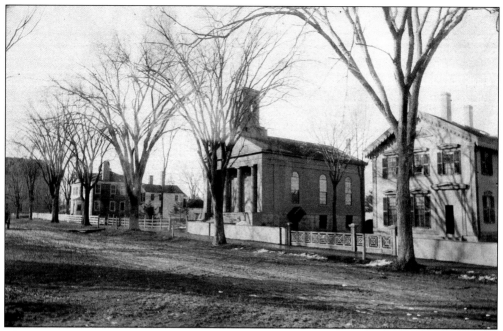

This Greek Revival building was the first meetinghouse of the Andover Episcopal Society, which became Christ Church. Built in 1837 with a significant donation from mill owner John Marland, this building burned down in 1886. Note South Parish Church down the road and the Christ Church rectory in the foreground, which was constructed in 1845.

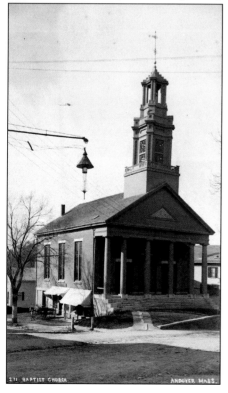

Constructed in 1834, the Andover Baptist Church leased its basement to Holts Provisioners for 99 years to pay its mortgage and construction costs. By 1924, the store left, and the church has since transformed the lower level into function and office space. It is the second-oldest church building in Andover.

Founded in 1850, the Ballardvale United Congregational Church originally met in the local schoolhouse. The church and parsonage seen here were built in 1875. In 1955, the church merged with the Ballardvale Episcopal Methodist Church. The church relocated to a new, larger facility in 1967. The old church seen here is now an apartment building.

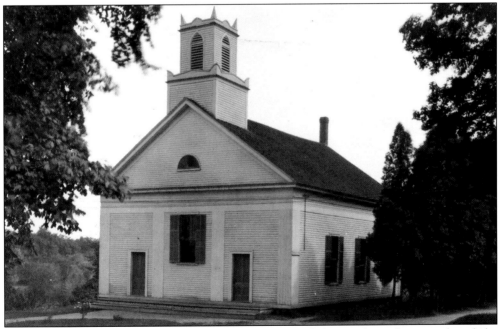

The Ballardvale Episcopal Methodist Church was founded in 1850 within months of the Ballardvale Unitarian Church. The original church building, seen here, was built in 1851. While the Methodist and Unitarian congregations began with pronounced differences in philosophies and beliefs, the two churches merged into the Ballardvale United Church in 1955.

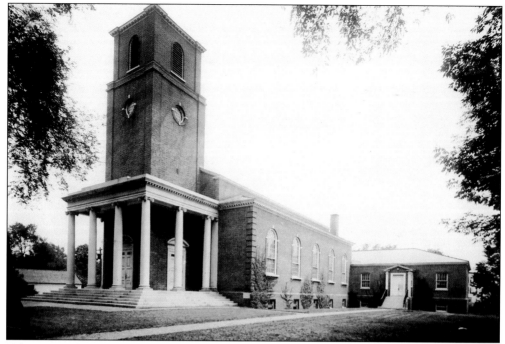

When several congregational leaders refused to address or actually forbade parishioners from discussing slavery during services in the 1840s, a group led by mill owners John Smith and John Dove split off and organized the Free Christian Church in 1847. The current church on Elm Street, seen here, was built in 1908.

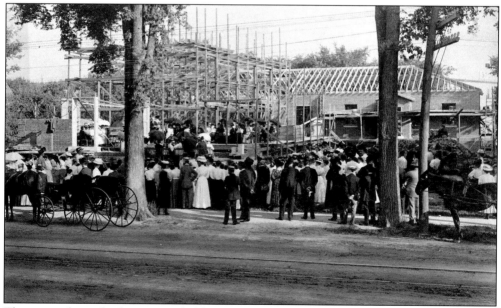

This image shows the first services held at the Free Christian Church in September 1908 before the building was completed. First gathering in the empty Universalist meetinghouse on Main Street, the parishioners later bought and relocated an empty church building to a site on Railroad Street before acquiring the current Elm Street property.

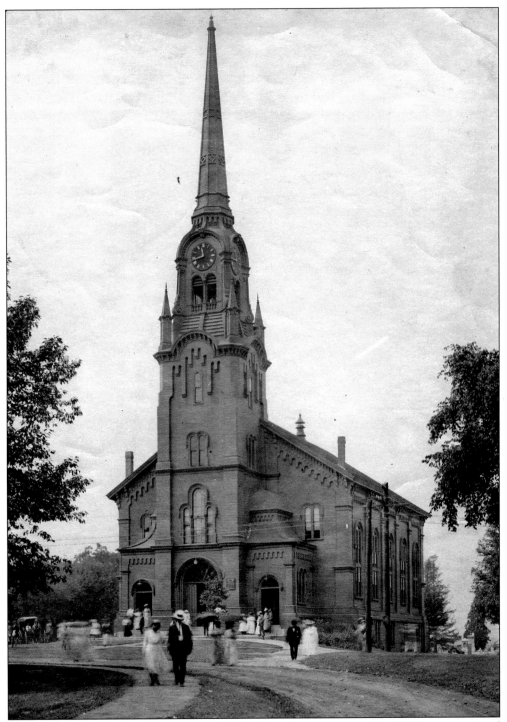

The current South Parish Church was painted white when constructed in 1861 but was painted brown for several years in the 1920s. This was done by many old New England churches to emulate the newer brick and stone churches built in the late 19th and early 20th centuries. By 1932, the building was returned to its traditional white.

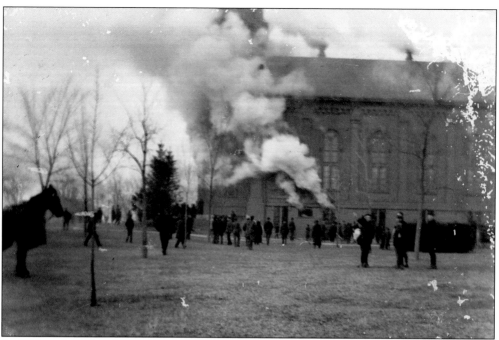

In 1901, a fire began in the basement of South Church. While no one was injured and the building was saved, the fire destroyed church records dating back to the early 18th century. This image shows heavy smoke billowing from the basement windows.

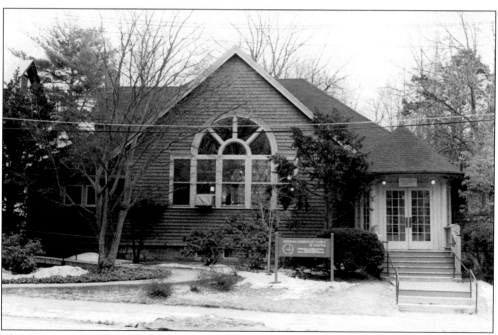

The First Unitarian and First Universalist Churches of Andover were both founded in 1847. In 1968, two congregations merged to form the Unitarian Universalist Church, later called the Unitarian Universalist Congregation. The group moved from west Andover to the former November Club headquarters, seen here, on Locke Street near downtown in 1985.

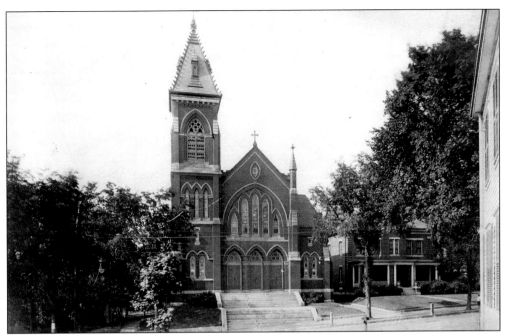

The first St. Augustine's Church was built in 1884 but was destroyed by fire only 10 years later. This church, completed in 1900, replaced it. The current church was designed by the architectural firm of P. W. Ford of Boston, which designed many other iconic churches throughout New England.

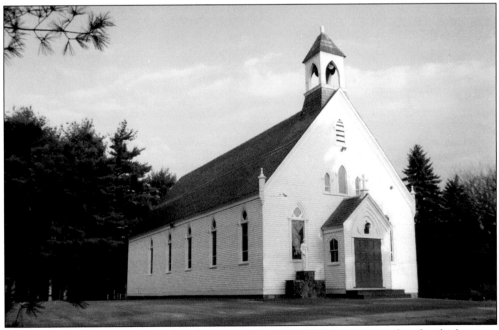

St. Joseph's Parish Church on High Vale Lane was begun in 1881 as a mission church, which means it was a satellite of St. Augustine's in central Andover, intended to serve the Catholic population in another part of town. St. Augustine's itself was founded as a mission church of St. Mary's Church in Lawrence.

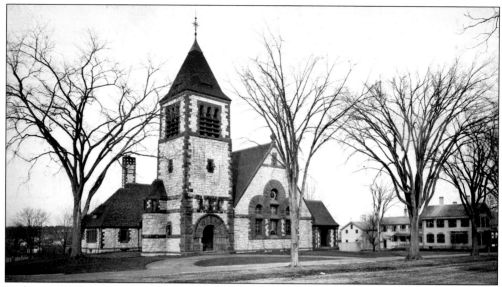

Built in 1887, less than a year after the first Christ Church burned down, this stone structure was donated by parishioner John Byers and designed by the famous Boston architectural firm of Hartwell and Richardson.

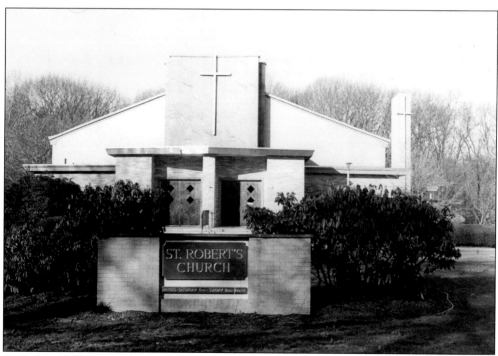

St. Robert Bellarmine Church on Haggett's Pond Road was founded in 1961 at the direction of Cardinal Cushing to accommodate the influx of new parishioners to the region during the 1950s technology boom. Robert Bellarmine is the 17th-century patron saint of religious education.

The Universalist Meeting House was built in 1828 on the corner of Punchard and Main Streets. The congregation was always very small and ultimately disbanded in the 1850s.The Andover Free Christian Church briefly used the building in the 1840s and 1850s. The town later purchased the building and used it as a schoolhouse for several years. The building was later moved to Bancroft Road and converted into a barn, as seen here.

Temple Emmanuel was founded in Lawrence in 1920. In 1979, the congregation moved to its present location on Haggett's Pond Road. In 1990, Congregation Tifereth Israel also relocated from Lawrence. After leasing space in other houses of worship, the congregation established a synagogue on South Main Street in 1995. In 2004, Tifereth Israel merged with Temple Beth El of Lowell to form Congregation Beth Israel.

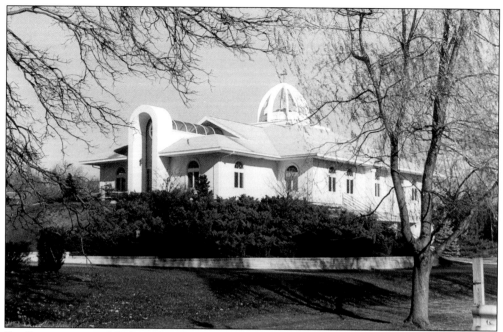

St. Constantine and Helen Church is a Greek Orthodox church. Established in 1917, the first services were held in an Essex Street storefront. The first St. Constantine and Helen Church was built in Lawrence in 1936, but the new church seen here was built on Chandler Road in Andover in 1988 to accommodate a growing membership.

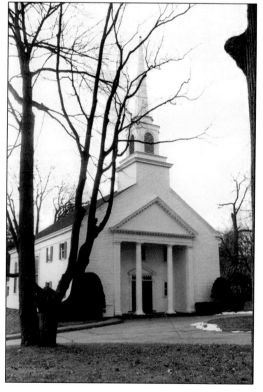

Built on land that was previously part of the William Wood estate along North Main Street, the Andover Christian Science Church was built in 1968 near the site of William Poor's 19th-century wagon shop. Cornelius Wood Jr., whose wife, Muriel, was a church member, donated the land and helped to defray construction costs.

Nine

SCHOOLS

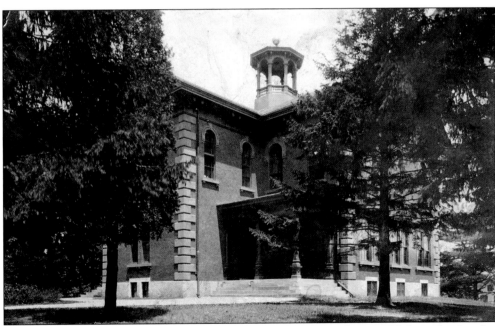

When Benjamin Punchard died in 1850, he left funds in his will to establish a school in his name. Punchard Free School coexisted as a quasi-private school within the Andover public school program, even operating from the same school building on Bartlet Street as the regular program for several years. Punchard Free School was officially absorbed into the Andover school system in 1901, creating Punchard High School.

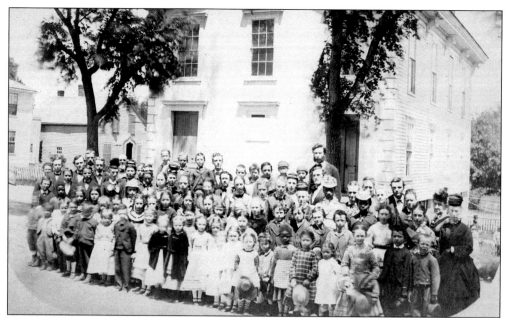

This 1875 image shows students from Richardson School, also known as Frye Village school, in front of the Frye Village meeting hall. The meeting hall held a library provided by the mill owners for the educational benefit of the workers and their families. Mill owners frequently provided educational resources and funds for construction of schools and libraries. Richardson School, built in 1848, was named after Warren Richardson, mill owner and early partner in the Smith and Dove mills.

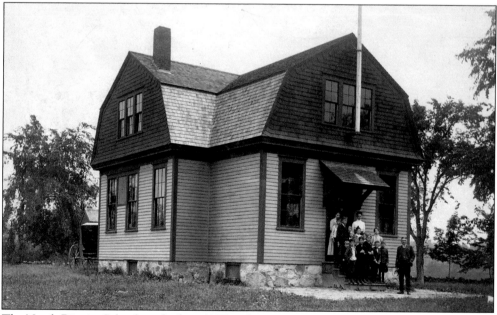

The North District School was built in 1895 at the intersection of North Street and River Road. It was the last one-room schoolhouse built in Andover. Expanded in 1914 to accommodate multiple classrooms, it remained open until the late 1940s. It was later used as a community center and demolished in 1984.

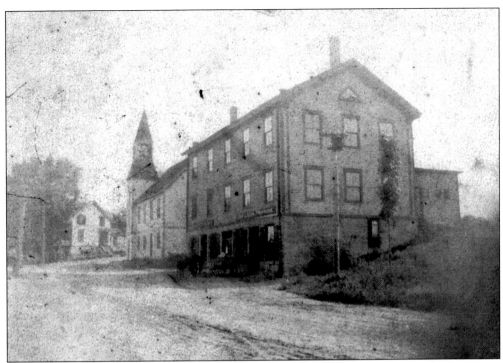

The Ballardvale Elementary School was so close to the railroad tracks that lessons had to stop as the trains rolled by. This image shows the school on Andover Street in the late 1880s.

Founded in 1778, Phillips Academy is the oldest private boarding school in the United States. The iconic Memorial Tower at Phillips Academy was erected in 1923 to commemorate Phillips alumni who perished in every war from the American Revolution to World War I.

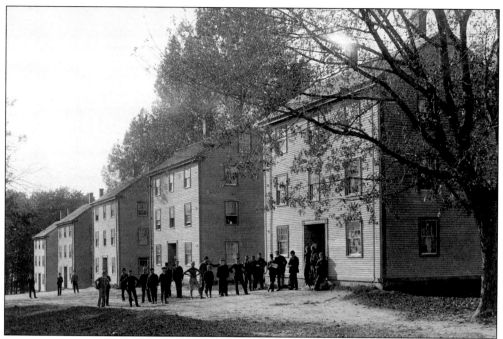

These student dormitories were some of the earliest on the Phillips Academy campus, built in the early 1800s on the Latin Commons. The buildings were spartan, lacking central heat or plumbing. Several of the buildings were demolished in the early 1900s, while the rest were moved to other locations in Andover to become private housing.

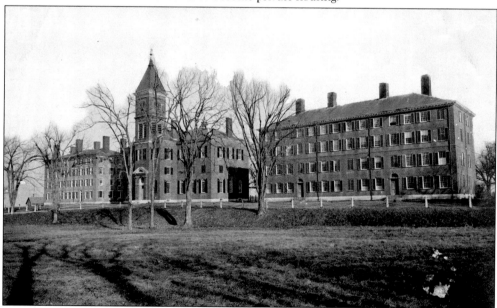

Originally conceived as part of Phillips Academy, the Andover Theological Seminary was instead established as a separate school to accommodate the large number of theology and divinity students. Notable alumni include Samuel Francis Smith, who wrote the poem "America," better known as "My Country 'Tis of Thee," while still a student, and Adoniram Judson, the first Protestant missionary from North America.

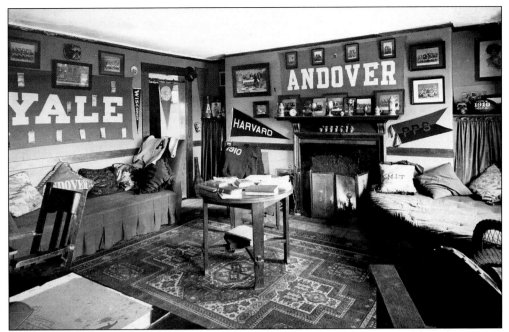

This is a typical room on the Phillips Academy campus from about 1910. It is significantly larger than a contemporary dorm room. Beds were camouflaged with throw pillows and blankets to look like sofas during the day. Pennants of various colleges share the walls with Phillips Academy banners.

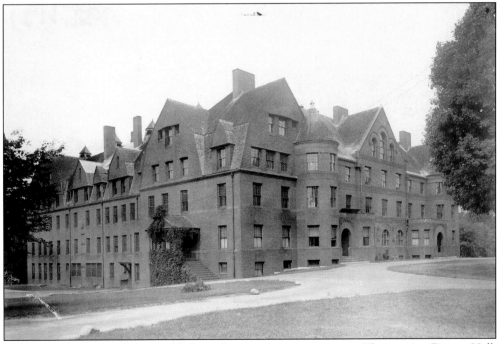

Abbot Academy provided a world-class education to young women. The massive Draper Hall, seen here, was named after Andover Press owner and academy benefactor Warren Draper. Built in 1890, it became part of the Phillips Academy campus when the two schools merged in 1973.

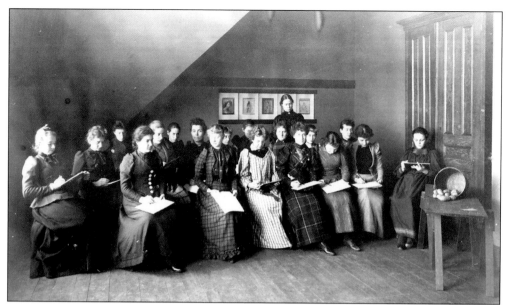

Classes at Abbot Academy focused on either college-preparatory courses or basic academics, depending on the era. Different school heads had radically different opinions about the importance of women's education and their place in society, causing occasional consternation to students attempting to complete a course of study. Social life was highly regulated, with scheduled group trips into town that took paths specifically designed to avoid the boys from Phillips Academy.

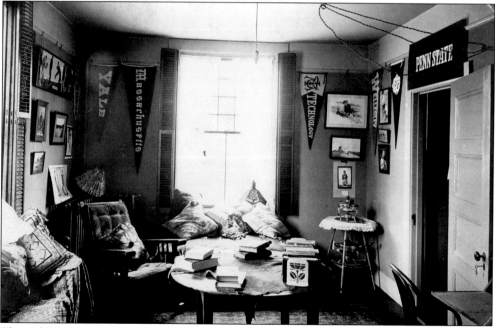

The girls' dormitories at Abbot Academy were decorated much in the same manner as those occupied by their male counterparts at Phillips Academy. Pennants hung include Yale University and the Massachusetts Institute of Technology (MIT) as well as Wellesley College, a prominent all-women's college.

Samuel Jackson School was built in 1904, the third of the group of schools along Bartlet Street that included Stowe School and Punchard High School. In its later years, Samuel Jackson School housed early special education classes before such programs were integrated into all school buildings. It was built in 1904 and demolished in 1981.

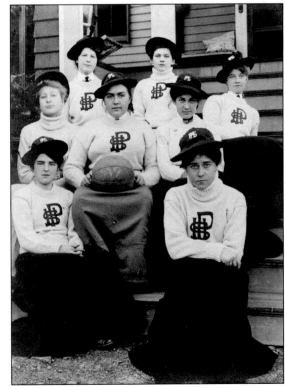

This image, taken in 1902, shows the Punchard High School girls' basketball team. Heavy sweaters and long skirts were worn even when playing, and the game was played on a grass court with the ball being bounced between players more than dribbled.

DISCOVER THOUSANDS OF LOCAL HISTORY BOOKS FEATURING MILLIONS OF VINTAGE IMAGES

Arcadia Publishing, the leading local history publisher in the United States, is committed to making history accessible and meaningful through publishing books that celebrate and preserve the heritage of America's people and places.

Find more books like this at
www.arcadiapublishing.com

Search for your hometown history, your old stomping grounds, and even your favorite sports team.

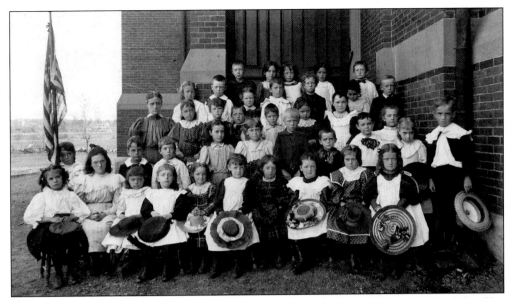

Photographer Charles Newman operated in Andover from the late 1880s until 1939. One of his most common subjects was the class photograph. This Newman picture shows the John Dove School fourth-grade class around 1910. Note the large open space behind the school, located on Bartlet Street.

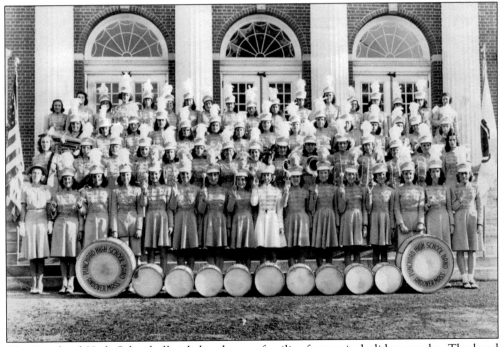

The Punchard High School all-girls band was a familiar feature in holiday parades. The band roster could number more than 100 musicians and majorettes. The powder blue uniforms worn by the band members were a familiar sight for parades and other events around Andover for many years.

Sacred Heart School was founded in 1946 and occupied the Andover Woolen Company administration building and playing fields until the 1970s. In this image, Cardinal Cushing poses with students on the front steps of the building. Today the building has been remodeled into condominiums.

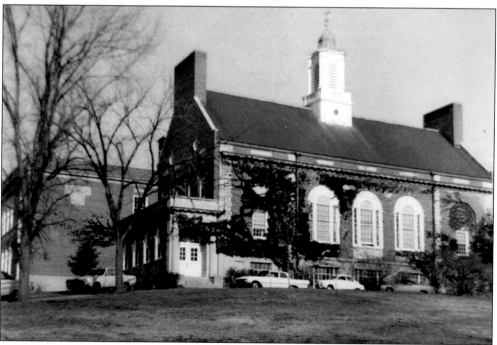

Built in 1924 as part of Shawsheen Village, Shawsheen School features details and fixtures designed by architect and artist Addison LeBoutillier. The school currently serves a preschool through second grade program.

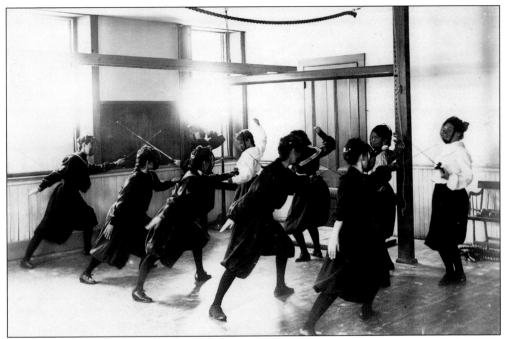

Abbot Academy was intended to produce not just an educated woman but a physically fit one as well. Competitive sports and physical activity were part of the regular curriculum. In this image, Abbot students practice their fencing skills.

Stowe School was built in 1888. Named for Harriet Beecher Stowe, it was built on Bartlet Street not far from her home. It was used as a school until 1971 and then as school administration offices until 1981. It burned down while deliberations were going on to decide whether or not to demolish the building.

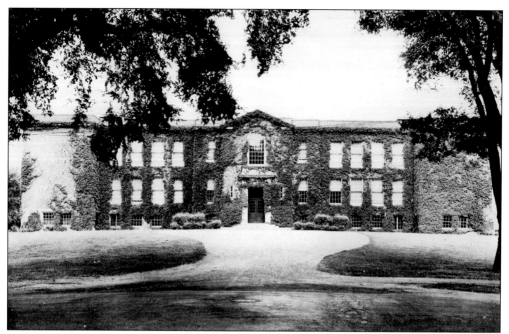

Punchard High School was established in 1901. The 1917 building seen here was significantly expanded in 1935 to accommodate Andover Junior High School. The high school relocated to new facilities on Shawsheen Road in 1957. Today this building is used as offices for the school department, town offices, and the Andover Senior Center.

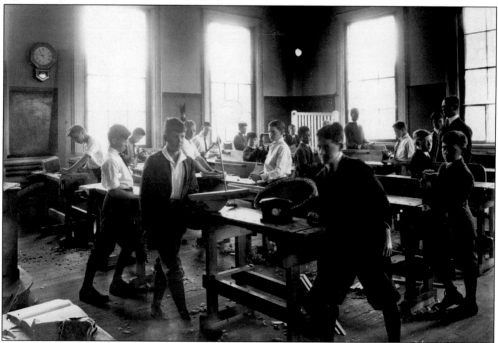

In addition to the traditional curriculum, John Dove School also provided vocational training. Here young boys proudly display their woodshop projects. Girls practiced sewing and embroidery in separate classes.